BEDFORDSHIRE
THROUGH TIME
Stephen Jeffery-Poulter

AMBERLEY PUBLISHING

Acknowledgments

The author would like to thank Nigel Lutt at Bedfordshire & Luton Archives for writing the introduction, as well as helping with access and research along with his colleague Pamela Birch and other members of staff. He is also very grateful to Alan for putting up with his sudden and repeated absences on those rare sunny Sundays, and to his parents in Pepperstock for providing a convenient stopping-off point for refreshments and suppers at short notice.

First published 2013

Amberley Publishing
The Hill, Stroud, Gloucestershire, GL5 4EP
www.amberley-books.com

Copyright © Stephen Jeffery-Poulter, 2013

The right of Stephen Jeffery-Poulter to be identified as the Author of this work has been asserted in accordance with the Copyrights, Designs and Patents Act 1988.

ISBN 978 1 4456 1618 6 (print)
ISBN 978 1 4456 1633 9 (ebook)

British Library Cataloguing in Publication Data.
A catalogue record for this book is available from the British Library.

Typesetting by Amberley Publishing.
Printed in Great Britain.

Introduction

We were delighted when Stephen Jeffery-Poulter approached us with the idea of a Bedfordshire volume in the *Through Time* series. The year 2013 is a significant one for Bedfordshire & Luton Archives Service as it marks our centenary as the first record office in Britain. What better way could there be to celebrate than a volume of picture postcards from our archives which, together with Stephen's modern photographs of the same locations today, show how the Bedfordshire landscape has changed over the last century?

Bedfordshire & Luton Archives Service has been caring for local archives since 1913, but we only began to acquire significant numbers of photographs and other illustrations in the mid-1950s. These included small collections of postcards from the golden age of the genre, roughly from 1900 to 1920, but we were always aware that we only held a small fraction of the cards produced commercially during that period.

All that was to change in 2007 when we acquired the collection of more than 7,000 postcards, photographs and printed ephemera assembled by the local Bedford architect, Alexander Chrystal (1929–2004), or Sandy as he was popularly known. Sandy Chrystal was the childhood friend – and later brother-in-law – of Bernard West, and the two men started their well-known architectural practice in Bedford around 1961. It was probably his appreciation of architecture and a general interest in Bedfordshire history that led to Sandy Chrystal starting his collection on his retirement in the late 1980s.

Sandy Chrystal's collection of postcards is a remarkable one in terms of the sheer volume, range and quality of the cards. Many are also quite scarce, for the postcard publishers naturally concentrated on Bedfordshire's tourist spots, such as river views, statues and gardens, rather than village scenes and the streets and shops in the new Victorian suburbs of the major towns. Many local photographers are represented in the collection: Blake & Edgar and Frank Sweetland (both of Bedford), John H. Copperwheat (Ampthill) and A. J. Anderson & Co. (Luton and Leighton Buzzard) to name just a few. For convenience, you will find our reference numbers of the images on each page.

Sandy Chrystal, 1929–2004

At the time of writing (June 2013), cataloguing of the collection is still underway, so Stephen's book will provide a 'taster' by bringing a small sample of Sandy's collection to a wider audience. Not only that, but Stephen's modern views, often taken after a good deal of detective work, provide a fascinating contrast with the postcard views of the past. I will resist the temptation here to launch into a diatribe against the often unsympathetic developments of the 1960s and '70s and the rule of the motor car, which has completely changed parts of Bedfordshire's landscape over the past century. Everyone who knows and loves Bedfordshire will have their own favourite places and a list of pet hates. I know I do.

As the author, Stephen thought it would be interesting to look at guidebooks and historical publications that appeared in the first fifty years of the last century when the period photographs featured in this book were actually taken. The four main works quoted from are:

Fea, Allan, *Quiet Roads & Sleepy Villages* (Eveleigh Nash, 1913) [referred to as 'Fea' in the text]
Gore Chambers, C., *Bedfordshire*, Cambridge County Geographies series (1917) [shortened to 'Chambers' in captions]
Page, William (ed.), *The Victoria History of the Counties of England* (Victoria County History, 1902) [an epic and encyclopedic series, the three volumes on Bedfordshire appearing between 1904 and 1912, shortly after the monarch to whom they were dedicated had died – referred to as 'the *Victoria*' in the text]
Mee, Arthur, *Bedford & Huntingdon* (1939) [part of his ambitious King's England series – just 'Mee' in the text]

Nigel Lutt
Archivist, Beds & Luton Archives & Records Service

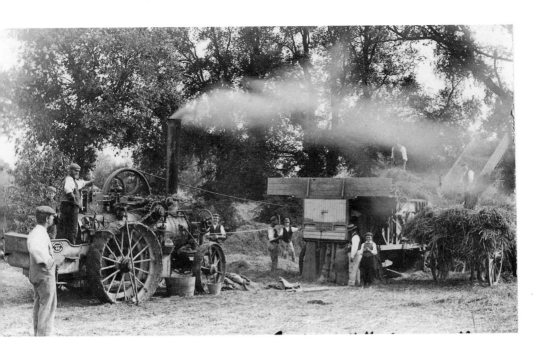

Rural Life

Before we go on to enjoy what is, for us, a nostalgic feast of lost rural scenes, it should be noted that life for agricultural workers at the turn of the last century was far from idyllic. Industrialisation and urbanisation had led to depopulation in the countryside and the plight of the 'rural poor' was a major social issue. The use of steam engines, as in this 1911 harvesting scene near Sandy, meant a significant drop in demand for local labour. Four members of the Millard family are assisted by three Shermans. Ironically some village forges, such as this one in Turvey, survived a little longer, as they were convenient to make basic repairs to this new machinery. (Z1306.99/Z1306.128)

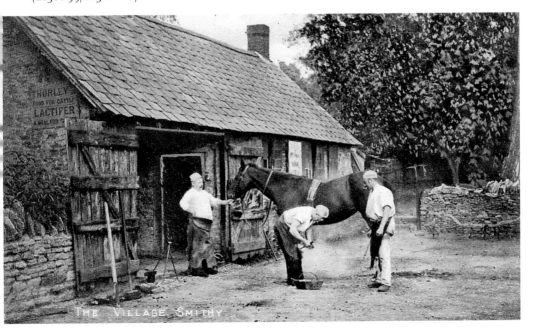

THE VILLAGE SMITHY

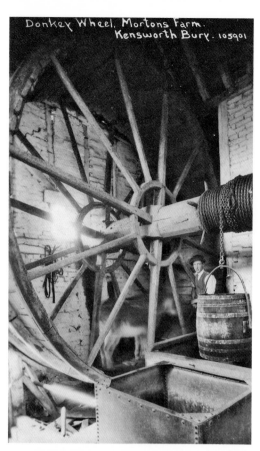

Donkey Wheel, Mortons Farm. Kensworth Bury. 105901

Country Living

The *Victoria County History* records that, 'Defoe, writing *c.* 1778, notices that Dunstable having no running water near is forced to draw water from deep wells *"by means of great wheels".'* In many parts of the county, farms had to improvise similar devices to get water from below the chalk layer – this donkey wheel in Kensworth was 200 years old and used a 30-gallon oak bucket. While townsfolk obviously found the 'express' (*below*) amusing, when the vast majority of country folk had to rely on 'shanks' pony' (i.e. their own two legs), having any horse-drawn vehicle was a much speedier alternative. Of course, local carriers' carts were the life blood of the rural transport system for centuries. (Z1306.68/Z1306.93)

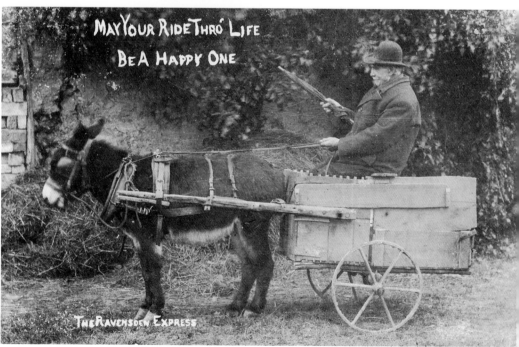

MAY YOUR RIDE THRO' LIFE BE A HAPPY ONE

THE RAVENSDEN EXPRESS

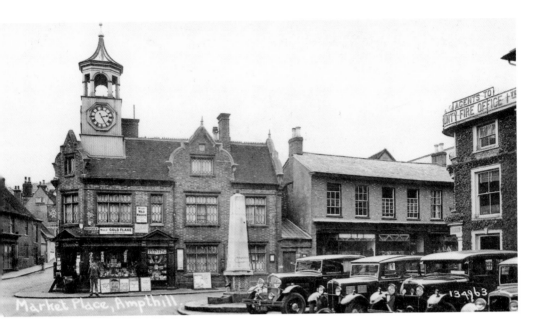

Ampthill: Junction of Bedford Road and Woburn Street

Reporting in 1939 at the beginning of his King's England volume on the county, Mee enthuses, 'A rare place to wander round is the Royal Honour of Ampthill with its gracious 17th and 18th century houses, a magnificent avenue of limes, and cross roads watched over by an old wooden clock tower.' The *Victoria* informs us: 'Formerly, there were houses standing incommodiously in the market place, which were pulled down in 1785, and a pump and obelisk erected in their place by the Earl of Upper Ossory. The clock tower, however, still remains, in which there are two bells, the first inscribed "R. C. made me 1710", and the other "Richard Chandler made me 1701".' (Z1306-1-12-9)

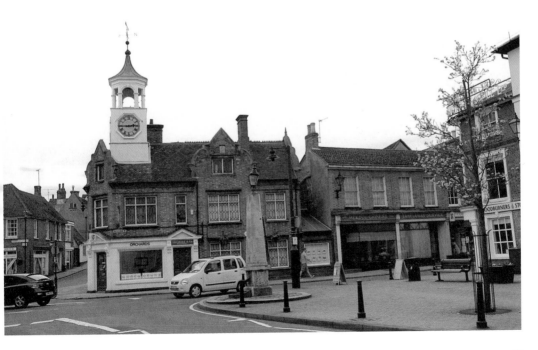

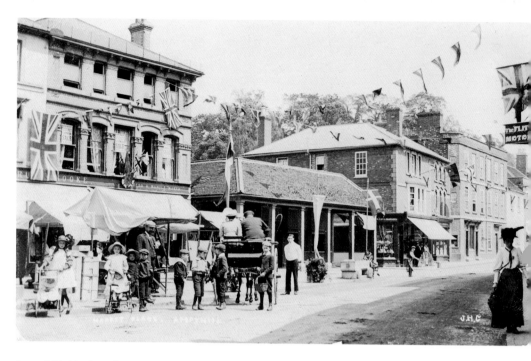

Ampthill: Market Place

This delightful photograph of the Market Place looking towards Church Street, taken by John Henry Copperwheat, shows the town decorated with flags and bunting for the show of July 1909. According to the *Victoria*, 'The market, which is held on Thursdays, was established in 1219 by grant to Nicholas Poinz and Joan his wife. It was confirmed to Joan Albini in 1242, who at the same time received a grant of a fair here on the vigil, feast and morrow of St Mary Magdalene.' Henry VIII's first wife, Catherine of Aragon, was banished to old Ampthill Park, just outside the town, and it was here that the hapless Queen was informed of the Royal Divorce issued by Cranmer. (Z1306-1-12-1)

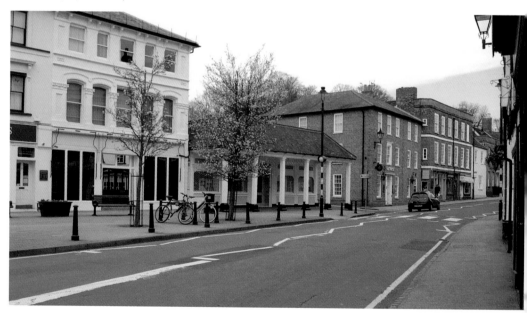

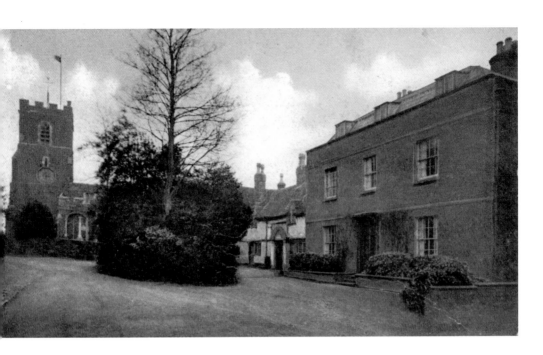

Ampthill: Church Approach

The church is situated on the eastern approaches to the town at the top of the hill leading down towards Shefford. Mee describes the scene: 'By a tiny secluded entrance square where a stately 18th century home faces a group of overhanging cottage almshouses, we come to Ampthill's church keeping watch over miles of loveliness, fir trees and the spur of a hill showing finely against the sky. The church is mostly 14th century, but the tower and battlements of the isles are 15th.' The picturesque Feoffee Almshouses were established before 1485, although the parts bordering the churchyard and to the right of the gateway were built in the nineteenth century. (Z1306-1-7-2)

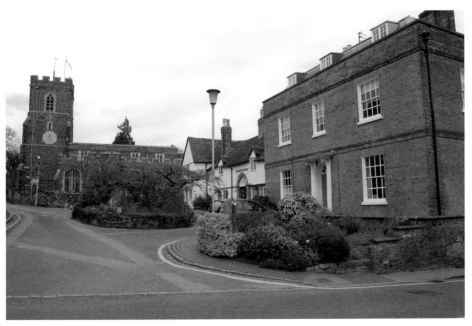

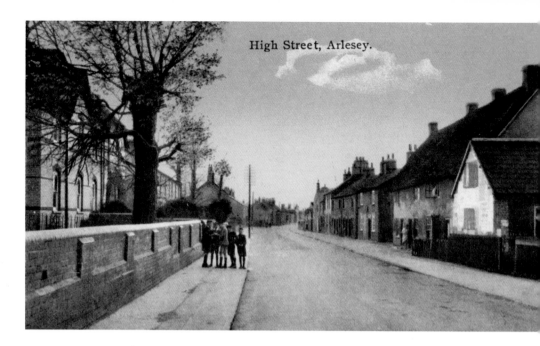

High Street, Arlesey.

Arlesey

'A straggling village some two miles in length with GNR stations at each end,' which, C. Gore Chambers tells us, 'has engineering, Portland cement, and large brick and tile works.' It is likely that the majority of the unusually large population of 2,046 in 1917 were employed by the three large brickworks to the north of the village. With the modern settlement now stretching over 3 miles, and the extensive changes that have taken place since the original photograph was taken, it was a real challenge to find the original location to match; especially as almost all the buildings in the foreground have been replaced with new housing, some of which has only been completed very recently. (Z1306-2-5-13)

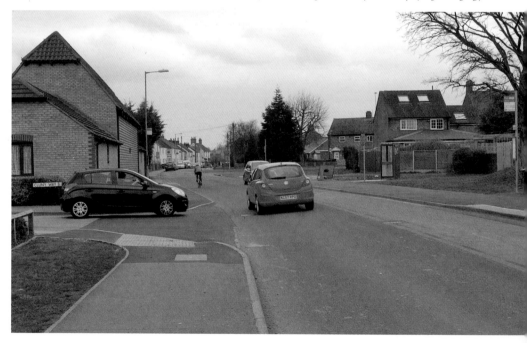

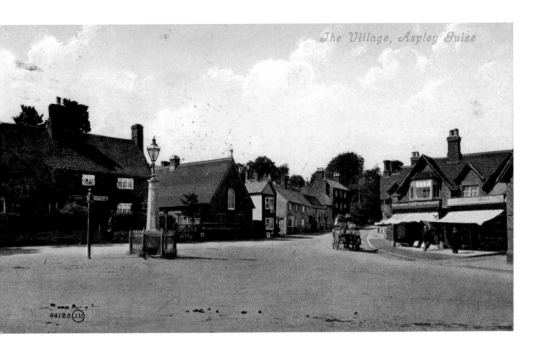

Aspley Guise

Mee's entry on this well-known health resort, renowned for its bracing walks, reads, 'It lies below the pine woods on the sandy hills round Woburn, a delightful place for splendid vistas all about. There are holly hedges 30ft high, great stretches of bracken growing out of silver sand.' The village, according to the *Victoria*, 'is well situated at four cross roads. Although much modernized, a few half-timber and thatch cottages still remain ... The Old House, the residence of Dr G. H. Fowler, a halftimber house of about 1575, with oak-panelling and fine plaster-work, and Oaklands, the residence of Mrs. Dymond, from which an excellent view over Woburn Park and the surrounding district is obtained.' (Z1306-3a-21-2)

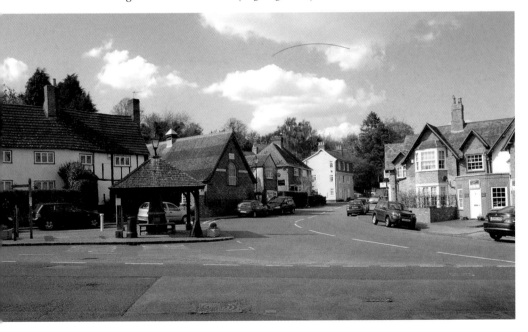

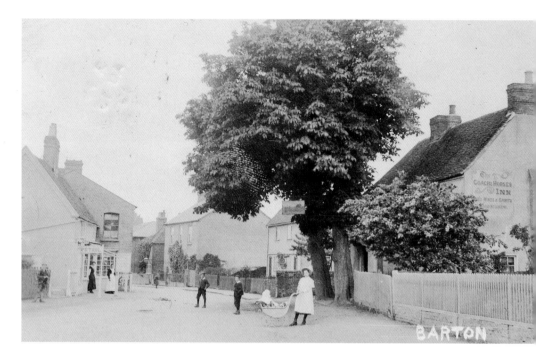

Barton Le Clay

'The village of Barton lies at the foot of the northern slope of these hills, along the Bedford and Luton main road,' the *Victoria* writes. 'There is an ancient round-house or lock-up, a red-brick building with a lead roof, but it has not been used for some years. The church stands at a little distance to the south-east of the village.' Everything on the right of the photograph has been rebuilt in the twentieth century – the original Coach and Horses Inn, in a sign of our changing times, today offers Indian Cuisine as the Café Goa. A petrifying spring at Barton, which turned wood into stone, is mentioned in 1738 in the *Atlas Geographicus*. (Z1306-7-3-14)

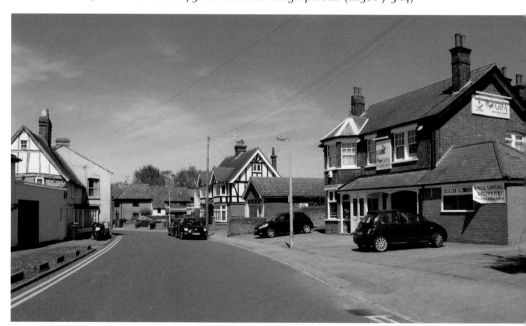

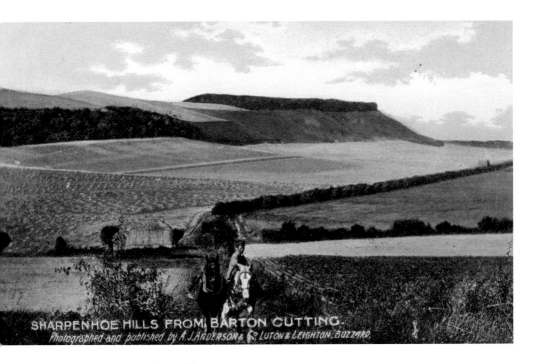

SHARPENHOE HILLS FROM BARTON CUTTING.
Photographed and published by A. J. ANDERSON & Cⁿ LUTON & LEIGHTON. BUZZARD.

Barton Le Clay: Sharpenhoe Hills

In *Bunyan's Country* by Albert J. Foster, published in 1901, the author identifies these hills with the 'Delectable Mountains' in the *Pilgrim's Progress*. 'Our author has somewhat embellished the Chilterns by clothing them with "gardens, orchards, and vineyards," for they are like all other hills of this geological formation, almost entirely naked and bare ... The sheep roam at will over the unfenced downs, and consequently we hear in this neighbourhood the tinkle of the sheep-bell, which is not common elsewhere.' Apart from the goalposts and neatly mowed grass in the foreground, the view today has hardly changed in a century – with the recent bypass constructed in a such a way as to leave this charming scene unspoiled. (Z1306-7-8-1)

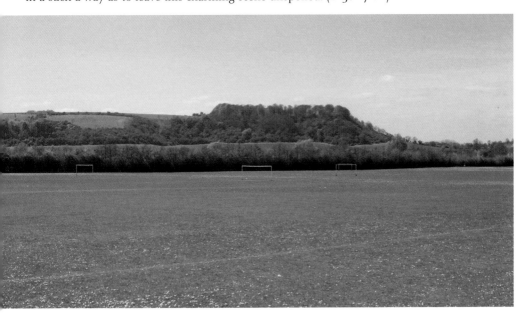

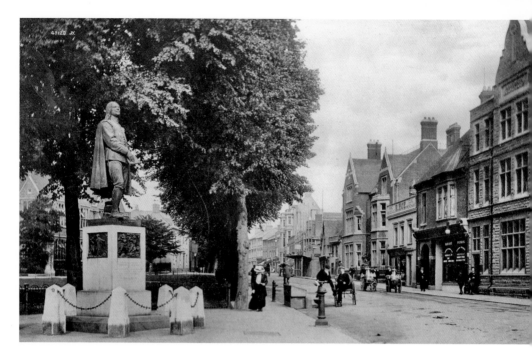

Bedford: St Peters Green

This impressive bronze statue of Bunyan, unveiled on 10 June 1874, celebrates the county town's association with the famous writer. According to Foster, it was while imprisoned here in '"the den"', as he calls it, that Bunyan 'in all probability wrote, or at least planned out, *The Pilgrim's Progress*.' The origins of the place, the *Victoria* conjectures, relate to a Romano-British defensive site at a ford. Having been occupied by the Danes and then liberated in the tenth century, 'in the great raid of 1010 the Danish army, moving down the Ouse, took Bedford and burned it. It may well be that the 10th-century "Abbey of Bedford" came to an end as a result of this disaster.' (Z1130-10-59-5)

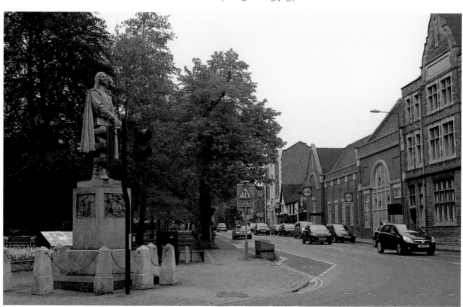

Bedford: Arcade

The *Victoria* records the rapid expansion of the town, 'exemplified by the increase of population from 3,948 in 1801 to almost double (6,959) in 1831, between which date and 1901 it rose to 35,144. The manufacture of straw plait and thread lace, together with the river trade in grains, timber and coal, had hitherto formed the main industries of the town, but by the middle of the century extensive works for the manufacture of agricultural implements, besides breweries, had been established.' By 1905, the building of a covered shopping arcade filled with Edwardian emporia clearly demonstrates how prosperous the town had become. In 2001, Mortimer's Tobacconist, now located in The Arcade, closed after 112 years in business. (Z1306-10-4-1)

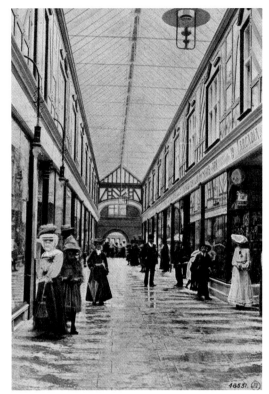

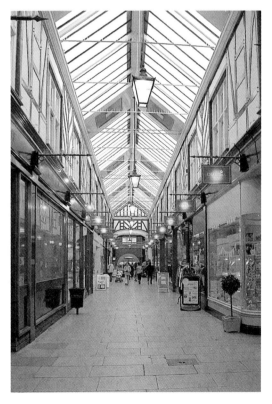

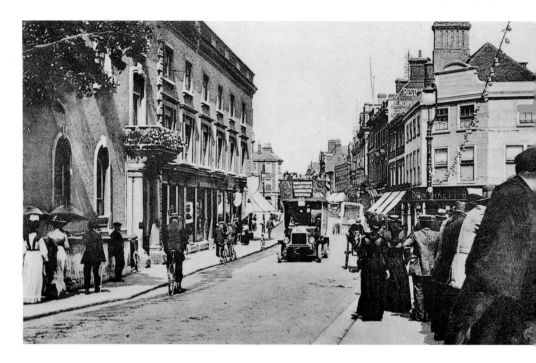

Bedford: High Street and St Paul's Square

'St Paul's Church with its square formed the natural centre of the town,' the *Victoria* explains, 'and here in the 13th century, as today, was the market place, then adorned with a market cross. The Moot Hall faced the High Street, which ran north to St Peter's Church and green. In the High Street stood the pillory, removed during the following century to a convenient place near "le gayehole", and branching off from the market place are found "le Bocher Row", of which the site is to be identified with that of the old Corn Exchange built in 1849.' Gilbert's 1894 statue of prison reformer John Howard can be glimpsed among the trees in the contemporary photograph. (Z1306-10-23-8)

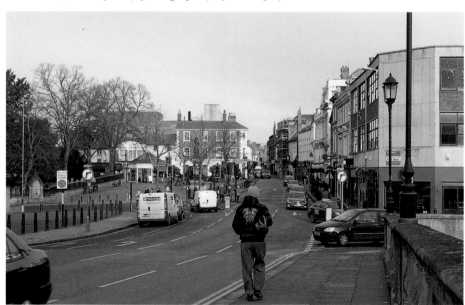

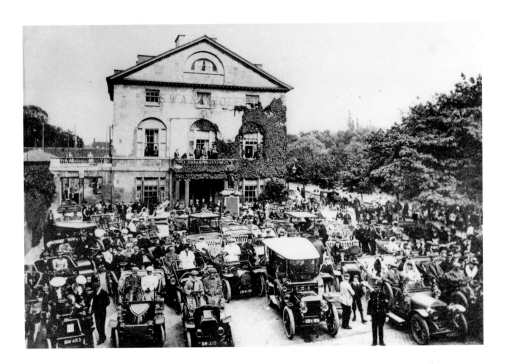

Bedford: Swan Hotel

The old Swan Inn was replaced by this elegant Georgian classical building between 1794 and 1796. Built by the Duke of Bedford, it became the main stop for the coaching trade for the next fifty years. The flanking arch on the right of the building was removed in the 1880s when the embankment behind was built. The 1907 photograph shows the inaugural meeting of the Beds Automobile Club on 26 June before the members set off to Bromham Hall. The *Bedford Independent* reported, 'Such a sight of forty odd motor cars formed up in the Swan square has never before been witnessed in Bedford, we believe, and crowds of people watched the proceedings with unfeigned interest, while cameras were everywhere at work.' (Z50-9-299)

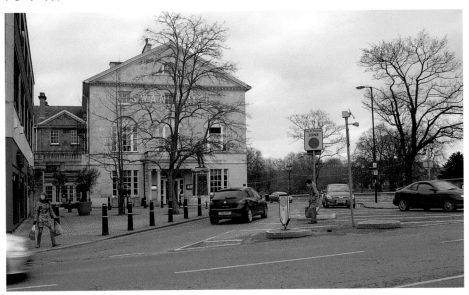

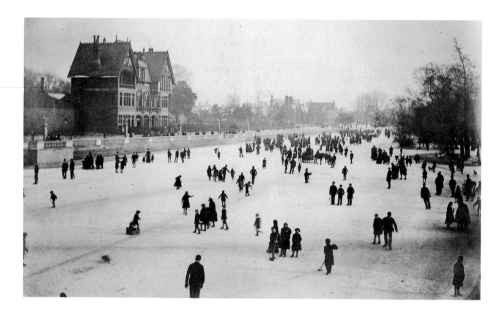

Bedford: River Ouse

This delightful Victorian photograph was probably taken during the severe winter of 1894/95. Chambers explains that 'the Ouse was once navigable to King's Lynn, but is so no longer, though there is much boating, and regattas are held ... From Bedford eastward to the site of Newenham or Newnham Priory the river banks have been laid out with gardens and ornamental walks.' The grand Town and County Club in the period photograph was relatively new, having been built in 1885. It later became the county library, but was demolished in 1971. Nearby is the site of Bedford Castle, built in the reign of William II as a motte-and-bailey fortification, which was levelled in 1224 after a successful eight-week siege. (BP28-10)

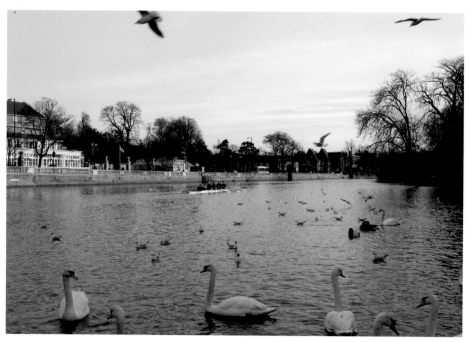

Beeston

Drivers speeding along the A1 will probably only be vaguely aware of this motley row of unkempt cottages due to the fact they have to slow to 50 mph for speed cameras. Hidden from view a few hundred yards off the dual carriageway is a rural village green. 'Round the green,' the *Victoria* observes, 'are many cottages, modern brick and slate intermingling with the old thatched ones.' In the sixteenth century the seven hamlets of this scattered parish were described thus: 'Two of them be ¾ mile from the church and every [one] of them as distant from other, and other two hamlets be a mile distant from church and every one of them as far distant from the other.' (Z1306.99.5)

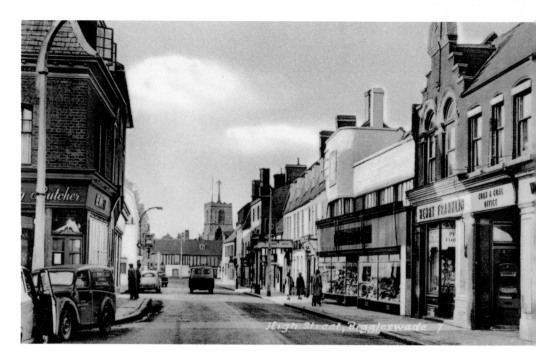

Biggleswade: High Street

According to Chambers a century ago, the town was 'much devoted to market gardening. There are fairs at Easter and on Whit Monday.' Mee updates us three decades later: 'It is all on the old Roman road where the River Ivel gives a quiet charm to the flat country around it, and the market place is quieter than of old, for it has lost much of its activity since Covent Garden became the true market for the country around. The fertile soil has a rich production which is almost entirely devoted to green vegetables. There is a water mill and a windmill.' The church is mainly fifteenth century, its tower being a landmark in the surrounding countryside. (Z1306-16-12-5)

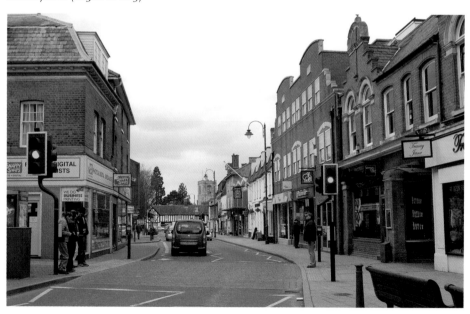

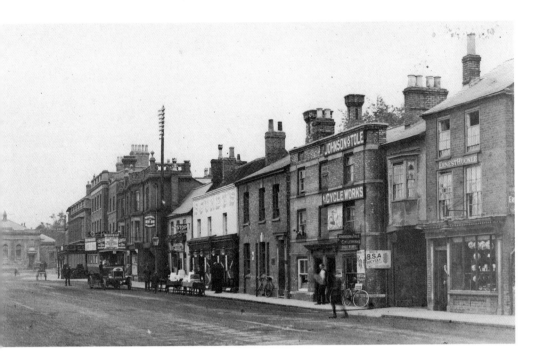

Biggleswade: Market Place

'The town was much damaged by fire in the eighteenth century,' the *Victoria* recounts. 'A note in the registers of June, 1785, records the destruction of 103 houses in five hours, which would suggest a predominance of half timber and plaster buildings. There are no domestic buildings of special interest, though the town can boast its fair share of the eighteenth-century red-brick fronts and doorways which form the chief attractions of so many country places, and as usual there are a few older timber buildings.' The modern infill has, at least, been built in proportion to the buildings they replaced, meaning the town centre still retains much of its period charm. (Z1306-16-15-14)

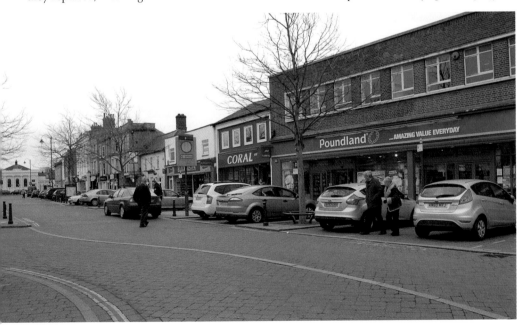

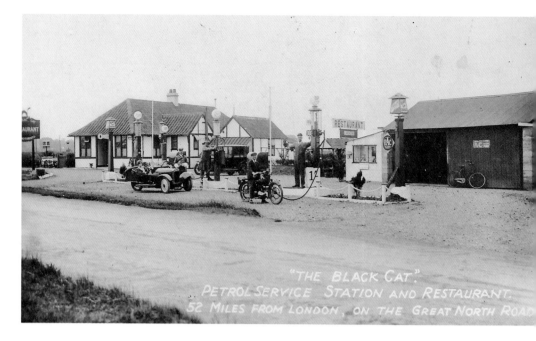

"THE BLACK CAT".
PETROL SERVICE STATION AND RESTAURANT.
52 MILES FROM LONDON, ON THE GREAT NORTH ROAD

Black Cat Roundabout

Even by the 1920s, the Black Cat Garage was clearly famous enough as a stopping point to warrant being featured on a postcard. When the original picture was taken, petrol cost 1s (5p) a gallon and was dispensed by uniformed pump attendants without a lady having to get out of her expensive, beautifully polished automobile. In later years, the garage became a nightclub and restaurant before falling derelict; the current petrol station and Little Chef were built on the site in the 1980s. A replica of the original metal cat sign was erected on the adjacent roundabout in 2004, reinstalled after the completion of the Great Barford bypass in 2006, and is still there today. (Z1306.121.2)

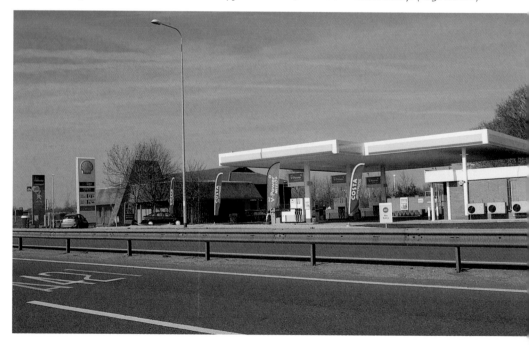

Bletsoe

'Pillow lace is made. The Falcon Inn was a favourite resort of Edward FitzGerald,' Chambers writes of this ancient manor, which appears in the Domesday Book. 'The cruciform church of St Mary is chiefly of Decorative period, and contains some fine monuments of the St John family. A portion of Bletsoe Castle still remains as a farm house.' The latter property was the birthplace of Margaret Beaufort, Countess of Richmond, and mother of Henry VII, who defeated and killed Richard III at Bosworth Field to end the Wars of the Roses. She would not recognise much of the interior of her neighbouring church, which was extensively 'restored' by the over-enthusiastic Victorians. (Z1306-18-10)

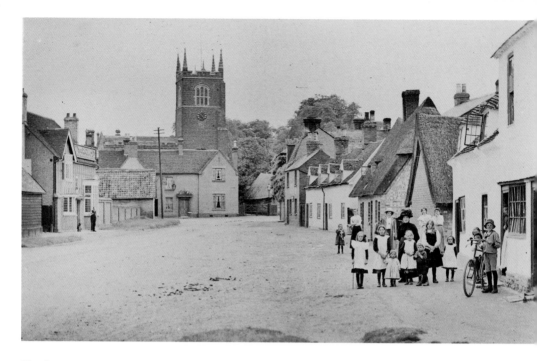

Blunham

The *Victoria*'s entry reads, 'The church stands in a large walled churchyard in the south-east of the village, the road here widening out to form a square, at the sides of which some old thatched houses are grouped. The old manor-house, a 17th-century building now used as a butcher's shop, is opposite the church. It was once the residence of Charles Earl of Kent, who died here in 1625.' Mee adds that the church contains, 'still preserved, the communion cup given by the poet John Donne, the ironmonger's son who became the Dean of St Paul's and was rector of Blunham in his last ten years.' (Z1306-19-1-2)

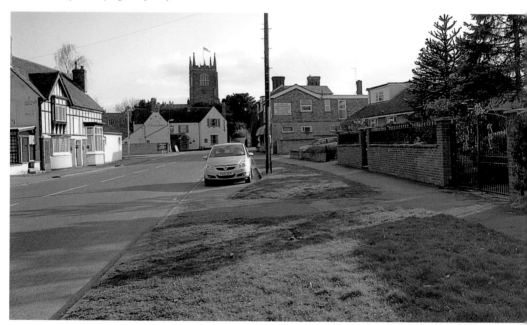

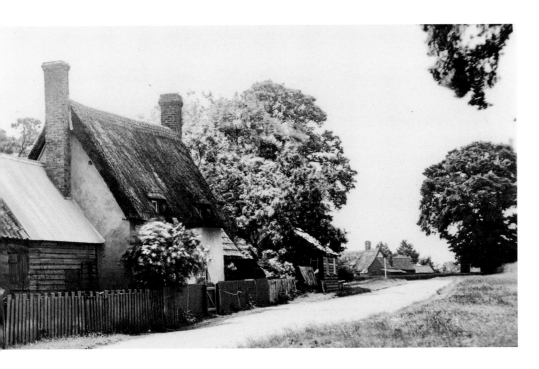

Bolnhurst

'Smithy and cottages, a moated farm, and a church across a field – this is Bolnhurst with its old embattled tower. In the churchyard is the base of an old cross,' Mee reports in 1939, of what remains a pleasant rural retreat. Half a century earlier, the *Victoria* gives more detail: 'The village stretches along either side of the road for upwards of a mile ... There are several farms in the parish; the Manor Farm, probably marking the site of the ancient manor-house, and Maverns Farm, an old building in the south-east of the parish, both having traces of moats. Greensbury Farm ... still possesses in an adjoining field a square half-timbered and tiled pigeon-house.' (Z1306-20-2-9)

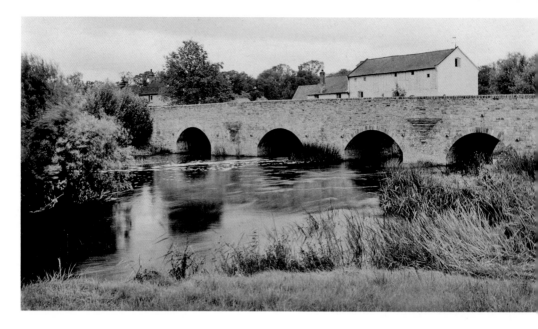

Bromham

Today, the half-timbered seventeenth-century mill, partly built from the stones of an ancient chapel, still dominates the view of the magnificent bridge of twenty-six arches, which has traversed the fast-flowing River Ouse since the thirteenth century. Except during flood time, the water only flows under the first four arches. Today the restored Bromham Mill houses an art gallery and café open on summer Sundays and Bank Holiday Mondays. 'The Hall,' Chambers recounts of a gabled house near the bridge, 'was held by the Royalists and captured by the Parliamentary troops.' The appropriately named Sir Lewis Dyve, who owned the property, was forced to escape the storming of his home by swimming down the treacherous river. (Z1306-21-7-3)

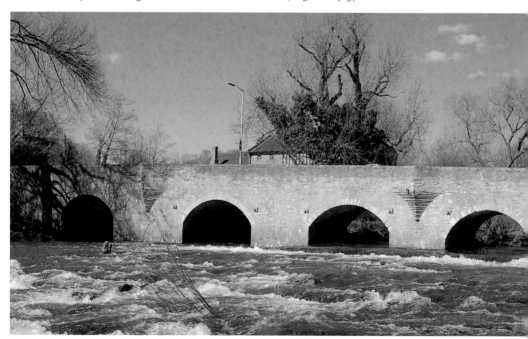

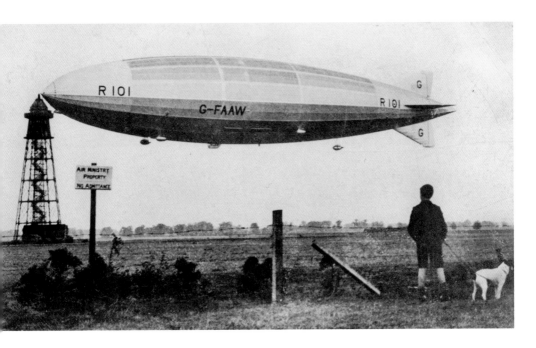

Cardington

Mee naturally excels in recounting the tragic tale of the 101 airship, which flew from the UK's foremost centre of aerial defence development on 4 October 1930. 'The storm raged furiously and torrents of rain beat down on her huge body, weighing her heavily ... Suddenly, with a frightful shock she struck the hillside. There was a crash and rending, a burst of flame; then a horrifying explosion of millions of cubic feet of Hydrogen. In a few seconds the noble product of all the labour of 2 years was reduced to a tangle of ruin.' Today, the great sheds still dominate the skyline behind the monument to the forty-eight men who died in the crash near Beauvais in France. (Z1306-24-20-3)

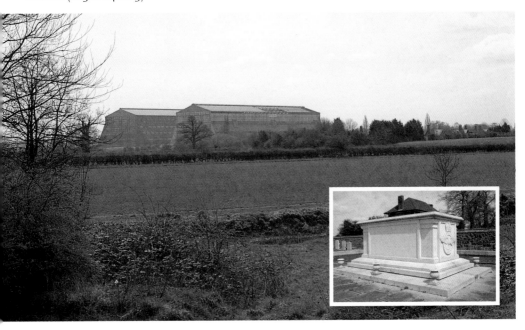

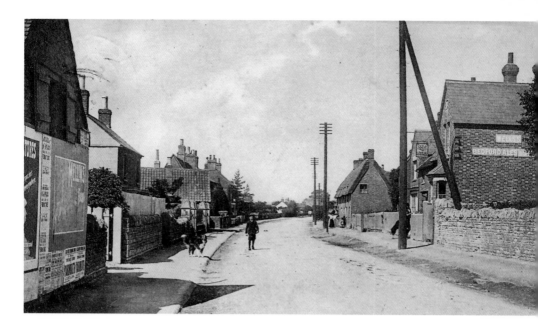

Clapham

Although of Saxon origins, the *Victoria* reports that 'the village is rapidly becoming a suburb of Bedford, and consists mainly of modern brick and slate cottages. The church occupies a position at the east end of the village ... There has been a recent revival of the lace-making industry in this parish, classes having been started in order to teach the art to the cottagers. Brick-making and lime-burning are carried on here.' On the western outskirts of the town, the disused Twinwood Second World War airfield now opens in the summer months, featuring various exhibitions. The Glenn Miller Museum commemorates the band leader, as this was the place he set off on his final, fateful flight. (Z1306.29.2)

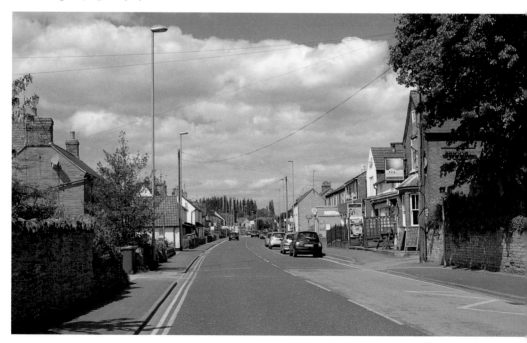

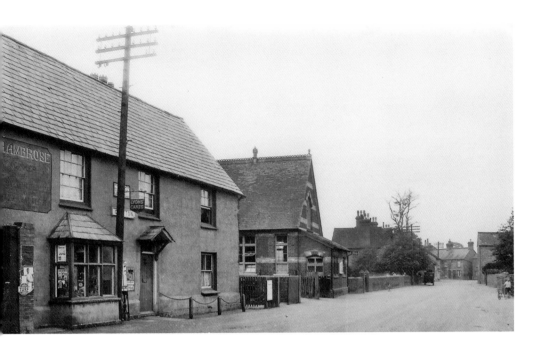

Clifton

'The population in 1901 was 1,283; the inhabitants are chiefly employed in agriculture, and a good deal of garden produce is raised,' the *Victoria* tells us. Although Mr Ambrose's grocery shop and the village school have been converted into private homes, the local infant school has moved to new buildings just next door. The village church, which celebrated its 600th anniversary in 1927, features two grotesque fifteenth-century gargoyles, 'yelling their soundless blasphemies and derisions to the wind'. Mee also reveals that 'under a corner of the nave is a rare possession for a village church, a charnel house into which bones were thrown as graves were cleared for newcomers.' (Z1306.30.1)

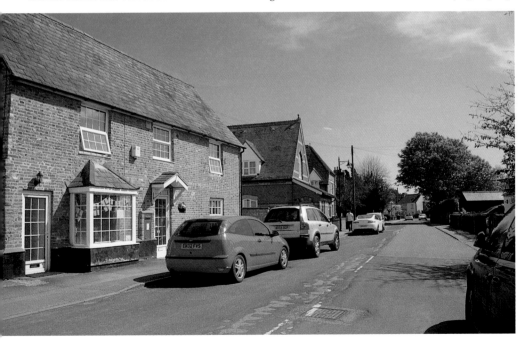

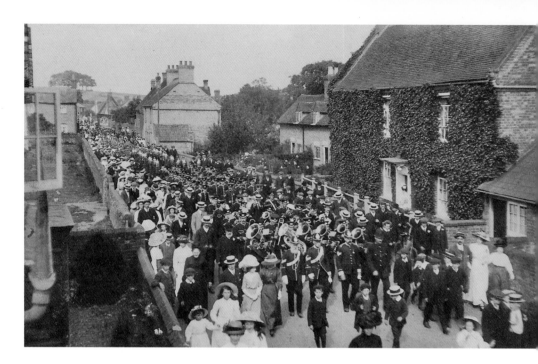

Clophill

'The village of Clophill straggles along by the side of the stream. Its ancient church, now no longer used for services, save as a burial chapel, stands at a distance on a high hill, and from the churchyard there is a beautiful view over the valley.' The joyous parade along the village street in July 1913 is en route from that church. And, according to Foster in *Bunyan's Country*, the riverside here inspired 'Bye-path Meadow' in the writer's work. 'It is all exactly as Bunyan describes it. The pilgrims were "not a little sorry", since "the river and the way for a time parted", and so they "were much discouraged because of the way".' (Z1306.31.2)

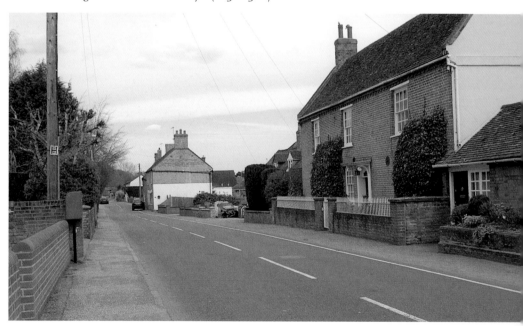

Colmworth

Mee, as ever, sums it up beautifully: 'A spire, seen at a distance, fits into the Lombardy poplars of the landscape. The church comes from the day the English were building again after the devastation of the Plague. For over 500 years the people of Colmworth have been opening its door with the great ring still hanging there.' One has to agree with the *Victoria*'s description of the fifteenth-century church of St Denis: 'Though small, it is of a scale and dignity rarely to be seen in a country church.' It continues, 'On a mound to the south-west ... stands the Manor Farm, which, although not old in itself, has traces of a moat round it.' (Z1306.32.1)

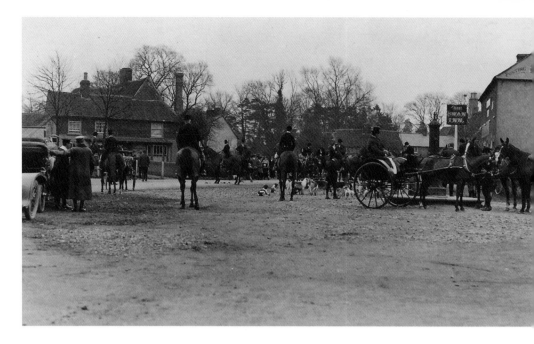

Cranfield

Here is Oakley hunt, gathered in all their finery for the 1909 Boxing Day meet outside the original Swan Inn. A smartly dressed chauffeur stands guard over his master's magnificent horseless carriage on the far left, while the horse-drawn carriages stand by the village pump on the right. But three decades later Mee asserts, 'All is changed in Cranfield. No more does corn come to the mill for grinding, no more do the women sit in their doorways making lace, no more do the men till the fields ... It is now the collectors of antiques who come to try to buy up the last few bone and ivory shuttles in the old cottages.' (Z1306.34.1)

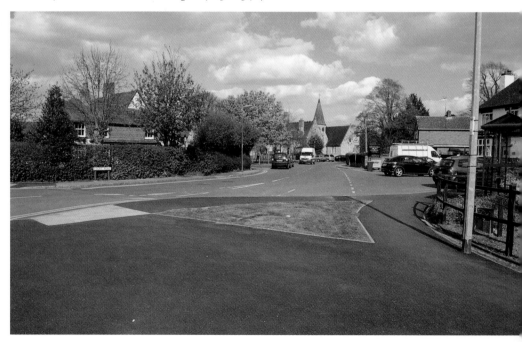

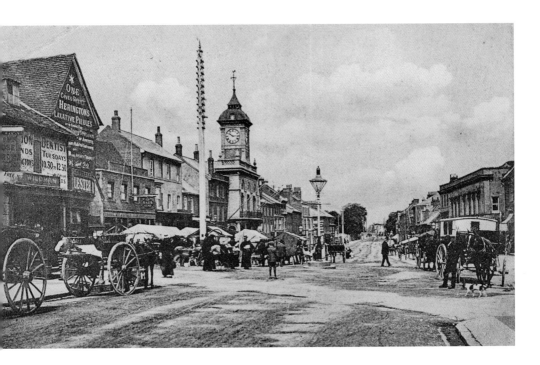

Dunstable: High Street

The *Victoria* recounts the eleventh-century tale of how this town got its name: 'Henry I, who recognised the dangers attending travellers on the Watling Street, caused the woods to be cut down and encouraged settlers by the promise of royal favour.' However, a notorious local robber named Dun exasperated the King, who fixed his ring to a pole in the highway by means of a staple and dared anyone to steal it. 'The ring and staple vanished, but were traced to a house inhabited by the widow Dun, whose son, the robber, was finally taken and hanged, but had the satisfaction of seeing his name and deed commemorated in the name of the newly-founded community.' (Z1306.36.4)

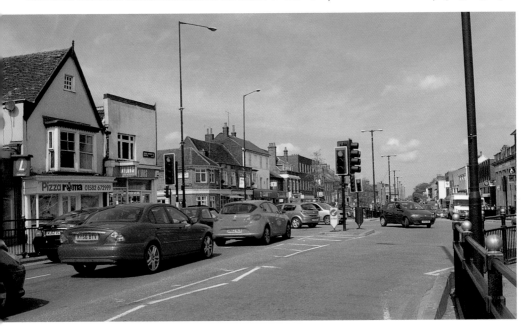

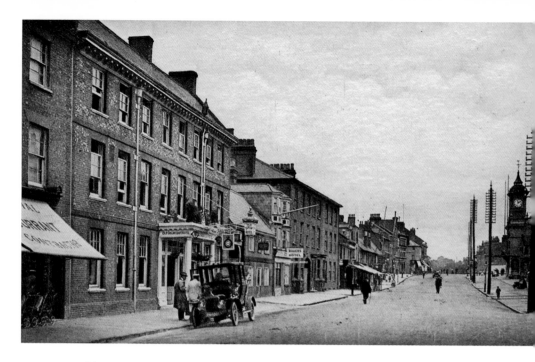

Dunstable: Sugar Loaf

'These roads made Dunstable one of the chief coaching centres near London', according to Mee's entry, with 'as many as 80 coaches stopping here, every one timed to a minute as we time our trains.' The *Victoria* tells us that 'the Sugar Loaf was built in 1717 and was the favourite place of call for the coaches when a halt was made for dinner. A formidable menu has come down to us, testifying to the heavy nature of the repast prepared for the traveller. The inn-keepers of this time well understood how to please their customers, and the inns flourished under their able guidance, justifying the remark of a gentleman who passed through Dunstable in 1793, that they were "remarkably elegant".' (Z1306.36.2)

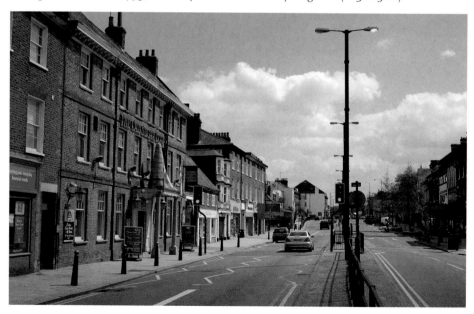

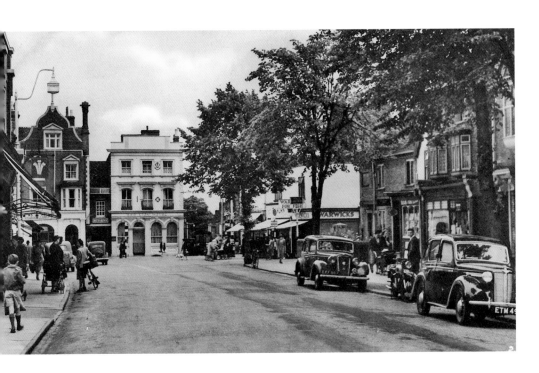

Dunstable: West Street

'Henry I founded here a Priory of Augustinian Canons,' Chambers explains, 'a portion of which still remains as the parish church of St Peter, which shows very fine Norman work in the nave.' 'Another industry, which dates from the 17th century, is the catching of larks, which abound on the Dunstable Downs. These, to the computed number of 50,000 a year, are sent up to London in the season,' the *Victoria* tells us. 'Their fame was spread abroad by the travellers of the coaching days, and a contemporary says "Dunstable larks are served up in great perfection at some of the inns in this town (owing to a peculiar and secret method in the process of cooking them)".' (Z1306.36.3)

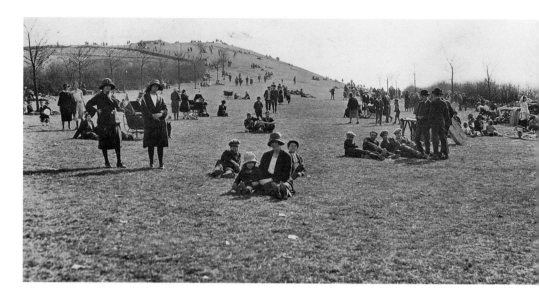

Dunstable Downs

'On the edge of the chalk and in the neighbourhood on the downs are many relics of prehistoric man; notably "Maiden Bower" ... and five round barrows,' Chambers reveals. But one suspects the people thronging the grass slopes during the interwar years, all in their Sunday best, are probably not here to search them out. Not long after, Mee stopped by and was filled with wonder. 'It is here we find men gliding marvelously in the air, pioneers of an incalculable future when men will fly as readily as birds, and perhaps as silently.' The gliding club still thrives; while today's visitors can enjoy an ergonomically designed centre with a shop and café offering delicious early-morning cooked breakfasts. (Z1306.36.5)

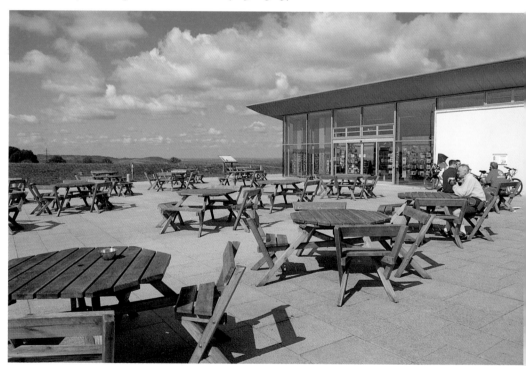

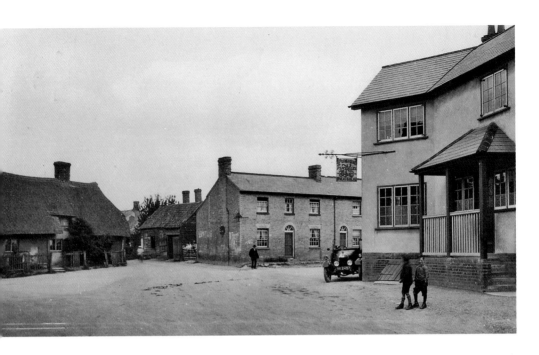

Dunton

Once this small village was a pub-crawler's dream, accommodating The Still and Sugar Loaf, The Boot Inn, The Three Horseshoes, The Wheatsheaf and The Pig and Whistle. Only The Wheatsheaf remains, although refurbished and renamed The March Hare – obviously with considerable success. The Pig and Whistle was replaced by a private house, while The Old Boot pub burned down in 1904 and was rebuilt on a more modest scale the following year. It ceased trading in 1927 and is also now a private residence. Cooper's village smithy in the middle of the photograph was demolished in the 1970s, no doubt to widen the road to for the convenience of modern vehicular access. (Z1306.37.2)

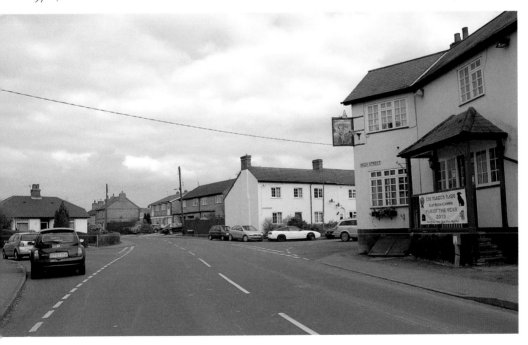

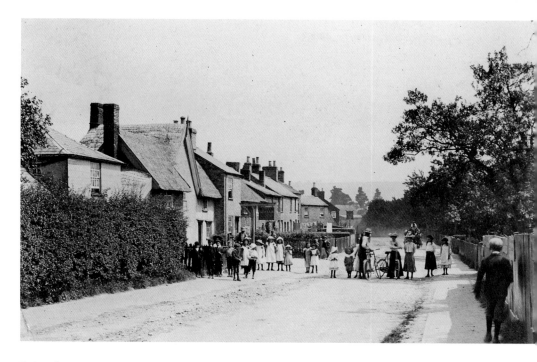

Eaton Bray

Half the children from this straggling village appear to have gathered in their Sunday best for this photograph, taken in 1905 outside the Fountain or 'Fountaine' Beerhouse. First licensed in 1845, the premises were put up for sale in 1881, with a rent of £7 per annum. The pub closed for the last time in December 1914. 'A speciality is made of the culture of carnations, the flowers being sent to the London, Manchester and Glasgow markets.' The *Victoria* continues, 'duck rearing was also started about twenty or thirty years ago and is still kept up by many of the natives ... A market for straw-plaiting formerly held on Fridays has long since been discontinued.' (Z1306.39.1)

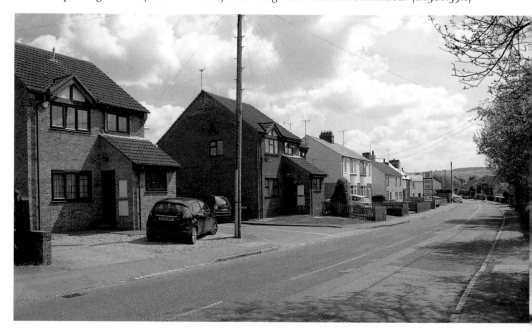

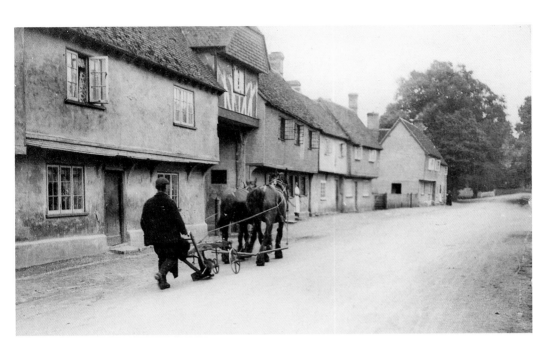

Elstow: High Street

'In the minds of most people, Elstow is connected only with the name of John Bunyan, but it had a history of its own long before his time,' according to Foster in *Bunyan's Country*. 'The name of the parish itself points us back to Saxon times ... for the word Stow, station or place, has been joined to the name of Helena, the mother of Constantine the Great.' When Chambers visited, the 'literary shrine' of Bunyan's Cottage had been 'so cleaned, scraped, re-cemented, re-glazed, and re-roofed that only the beams within give any real idea as to its actual age.' This Victorian 'restoration' wasn't enough to save the place from demolition by Bedfordshire County Council in 1968. (Z1306.43.2)

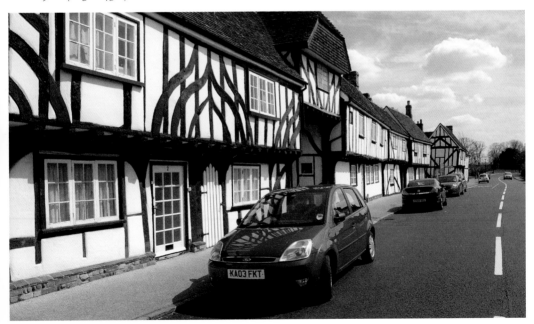

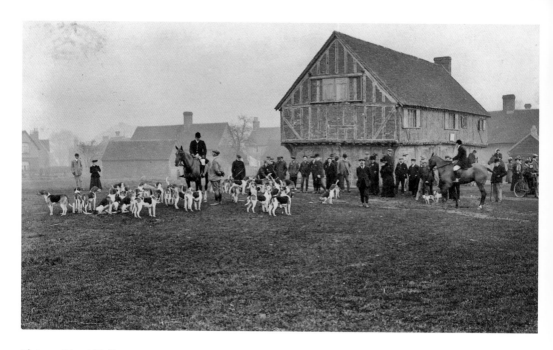

Elstow: Moot Hall

'Here stands a fragment only of the village cross, and a bow-shot away is the Old Moot Hall, of timber and herring-bone brickwork, with narrow Gothic doorways in the oaken framing,' Chambers observes. 'This market house looks forlorn and odd standing practically in the middle of a field.' 'Originally on the ground floor were several shops, and many of the four-centred doorways in the timber frame are still to be seen,' the *Victoria* reports. 'On the first floor were two rooms, a large hall to the west and a smaller room on the east, both being the full width of the building. John Bunyan is erroneously reputed to have preached here ... The ground floor is used as a lumber store.' (Z1306.43.3)

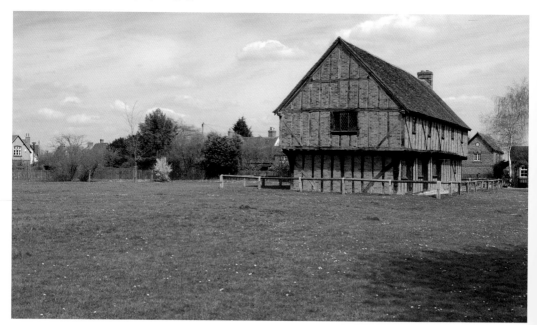

Eversholt

The *Victoria* entry reads, 'The parish of Eversholt, covering an area of 2,145½ acres, contains no village proper, but consists of several clusters of houses ... The church of St John the Baptist and the schools are in the south at Church End.' Mee takes up the tale: 'The Rector lives in a Georgian house and many of his people in cottages much older, all of them by the road which dips to the Woburn woodlands where the Normans hunted the boar. The church has grown throughout the centuries. It has still a Norman pier, the font is 13th century, the chancel 14th, and the striking embattled tower is of the last great building century, the 15th.' (Z1306.44.2)

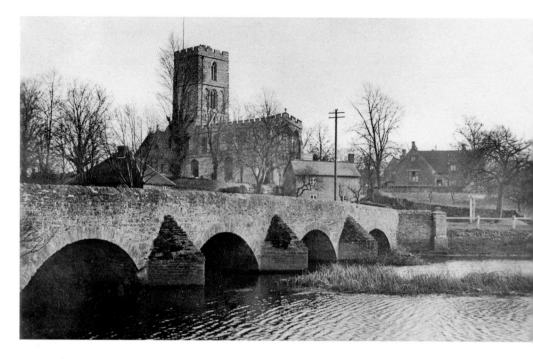

Felmersham

Mee waxes lyrical about this idyllic spot: 'By the great buttressed tithe barn, beautifully set on a hill over-looking the ford, stands one of the finest 13th century churches in Bedfordshire ... described by an old friend as keeping watch over the quiet river and looking down like a kindly mother on the homely little village nestling among the elms and chestnut trees.' The *Victoria* recounts the local legend that an area of land opposite the church was given 'for furnishing grass to be laid in the church at Whitsuntide, by a person who, having lost his way on a dark night, would have fallen into the river at this spot had he not heard Felmersham Church clock strike.' (Z1306-48-2-4)

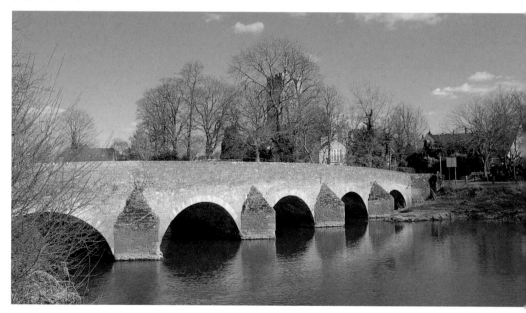

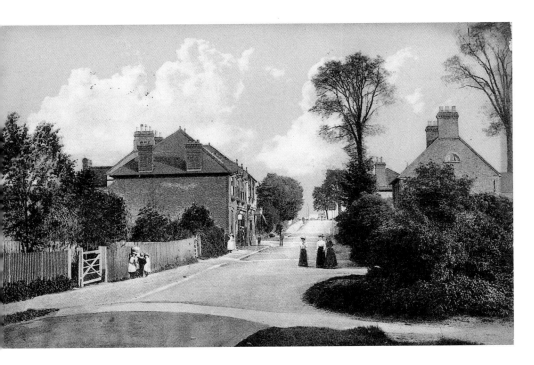

Flitwick

Perhaps better known today for its railway station than for the River Flitt, which gave the village its name, it was split into the old area of Church End to the south and East End, formerly known as Easton, built mainly after the arrival of the railway. By the dawn of the twentieth century, Chambers reports a population of 1,424. Dear old Mee was still able to locate some rural charm in 1939: 'Down by the Flitt lies the boggy Flitwick Moor to rejoice the collector of rare plants, for on it grows the little sundew that feeds on midges and flies, capturing them with red tentacles which curl around the victim and absorb its blood.' (Z1306.50.1)

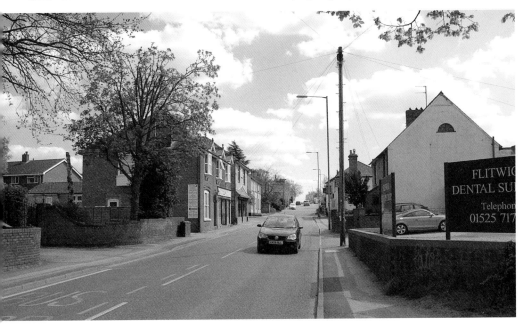

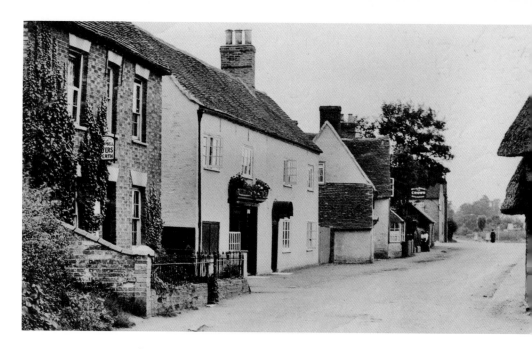

Great Barford

'The village is large and scattered,' the *Victoria* reports, as if such a phenomenon was virtually unknown in Bedfordshire! 'It contains some good residences and cottages of every date and style from the 17th century onwards. In the northern part of the village, known as Green End, is the site of Creakers Manor ... The parish church of All Saints stands near the bridge in a beautifully kept graveyard. Near the vicarage, which is adjacent, were till recently to be discovered traces of the village pound.' One of this charming rural hamlet's main claims to fame is that it was the place where the first ever legal inquest took place in England in the twelfth century. (Z1306-5-10-7)

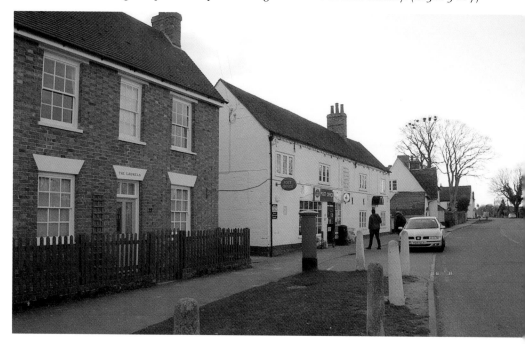

Harlington

Another disparate village, this time split into three parts, founded by the Anglo-Saxons as the 'Hill of Herela's People'. It is listed in the Domesday Book, and by the late thirteenth century had a church and manor house; however, in 1349 a quarter of the population was killed by the Black Death. 'Its thatched and timbered cottages climb up the hill to the church,' Mee observes. 'A famous history has this little place, for here it was that John Bunyan said goodbye to freedom and took up his heavy cross.' He was arrested in 1660 for preaching and spent the night at Harlington House en route to Bedford Gaol. The picturesque Carpenters Arms pub first appears in local records in 1790. (Z1306.53.2)

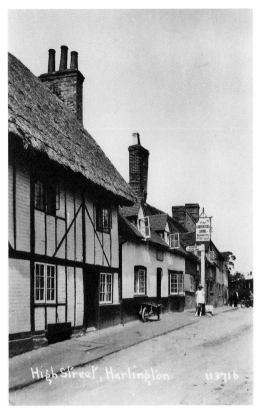

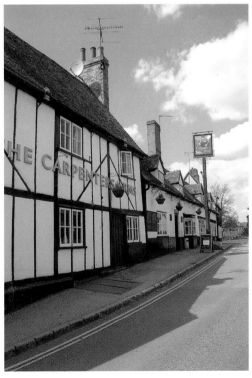

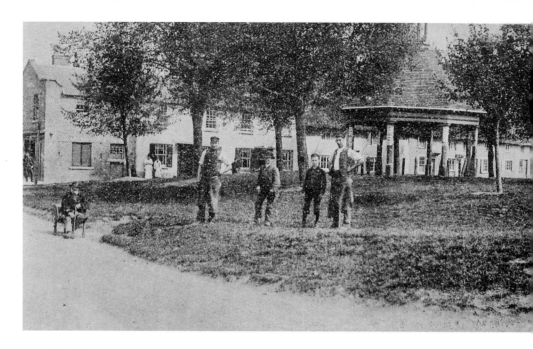

Harrold: The Green

'It has one of the most attractive churches in the county, one of the quaintest market houses, and a little round lock-up with a dunce's cap roof,' Mee's entry tells us. 'The market house was built at the close of the 17th century in classical style, with eight wooden posts and a cornice.' With regard to the Buttermarket, the person who sent this postcard in 1908 told the recipient, 'You would like it when the band plays there.' The green today is every bit as picturesque, so hardly surprising to find *The Times* selected this prosperous village in 2013 as one of its '100 Best Places to Live in Britain' calling it 'a true hidden gem'. (Z1306.54.1)

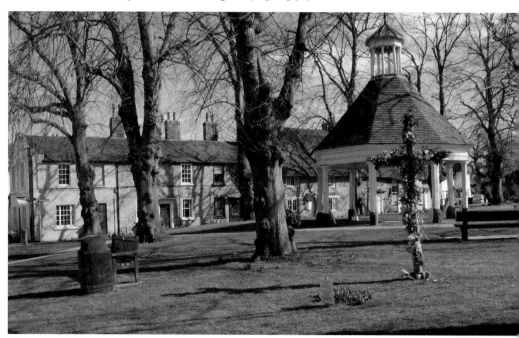

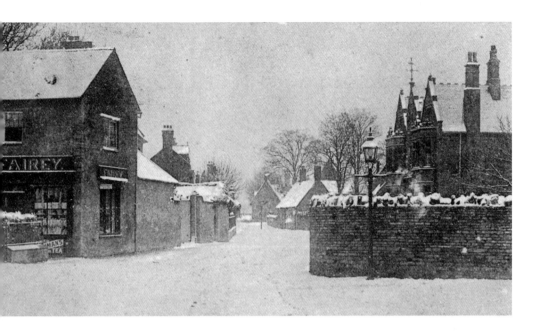

Harrold: High Street

A charming snow-covered scene from the turn of the last century features the Fairey's grocer's on the left, and the gothic grandeur of Harrold House on the right. Nothing has changed in a century, except that the new owners, the Co-op, have extended the shop for the convenience of modern consumers. The *Victoria* found it noteworthy that such a small settlement should be lit by oil lamps. 'Harrold appears to have been at one time a market town. The market was held on a Thursday, and … was obtained by charter about the beginning of the 17th century.' The approach to the village is across a very narrow, six-arched bridge, which has spanned the river for 900 years. (Z1306.54.2)

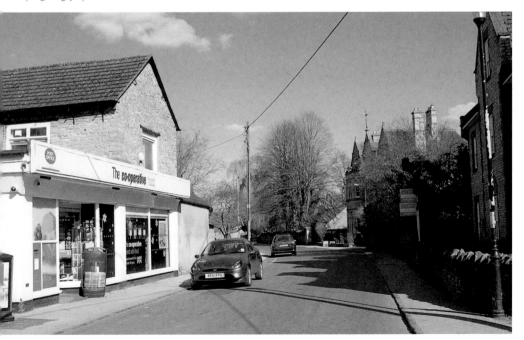

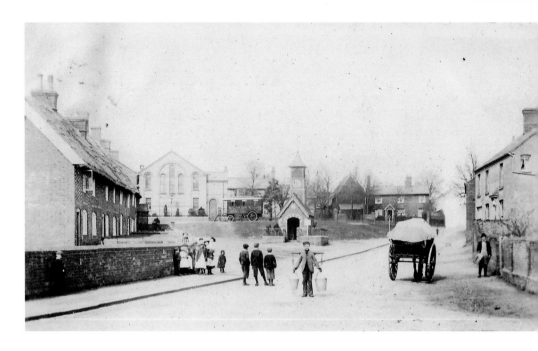

Heath & Reach

According to *Kelly's Directory for Bedfordshire 1890*, this village 'is remarkable and picturesque, covering several hills and valleys, with pleasant landscapes stretching away into the distance with beautiful woods and plantations. The church of St Leonard, rebuilt in the year 1829 ... is a plain, modern building in the Gothic style, consisting of chancel and nave, and a low embattled western tower containing one bell.' The population of 1,090 had a reading room, a post office run by Amos Roberts, with Mr and Mrs Martin in charge of a mixed national school. One of the local sandpits was the source for the sand used to manufacture glass for the famous Crystal Palace, its architect, Joseph Paxton, having being born locally at Milton Bryant. (Z1306.57.1)

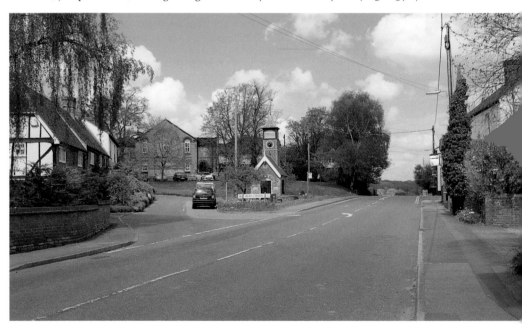

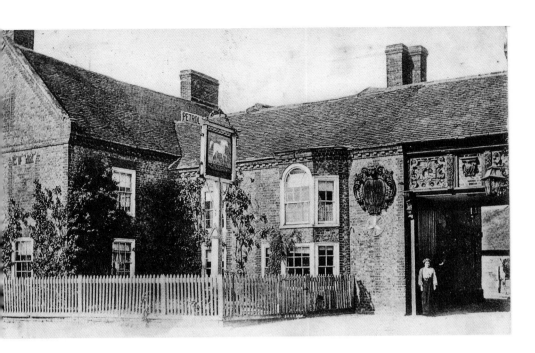

Hockliffe

'Hockliffe at one time enjoyed an unenviable reputation for the bad condition of its roads,' the *Victoria* reports. 'In 1633 Sir Edward Duncombe, as the result of a complaint of the justices of the county, writes to Secretary Windebank that there is no truth in the complaint, and that he has always kept the road ... in good repair, and intends to lay yearly on the same 400 loads of gravel and stone.' A century on from this 1906 view, the rather grand White Horse Hotel has become residential and considerably worse for wear and weather is the once-fine Elizabethan wood carving that adorned its façade, 'said to come from Toddington Manor. Two coats of arms can be distinguished.' (Z1306.60.1)

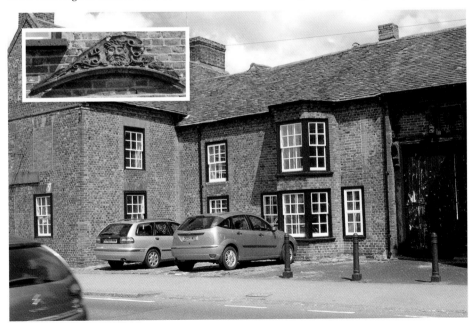

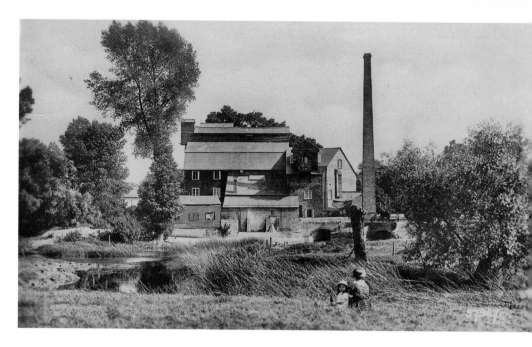

Kempston

An ancient village, Chambers explains, but industrialisation has led to 'an increasing population [5,349]. Here, in the extensive gravel pits, many palaeoliths have been found and, some years ago, large Romano-British and Anglo-Saxon cemeteries.' The *Victoria*'s entry tells us that 'where the river divides in two and forms an island, are a large corn-mill and the gasworks, founded by Mr E. Ransom in 1869 ... There was a mill on the manor of the Countess Judith at Domesday worth 5s, which was given by her daughter Matilda to the abbey of Elstow and held by the nuns until the Dissolution.' The corn mill has recently been reincarnated as a complex of desirable riverside residences. (Z1306.67.1)

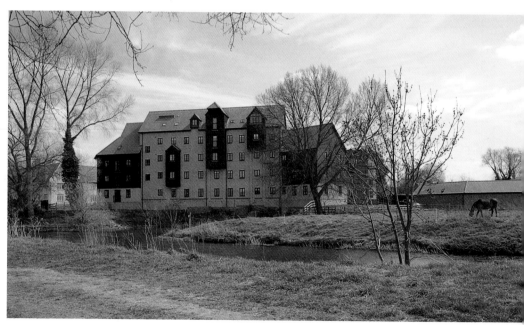

Keysoe

In *The National Gazetteer of Great Britain and Ireland 1868* we read, 'The village is small and scattered. The inhabitants are chiefly employed in agriculture. The land is chiefly arable, with some pasture, and 350 acres of woodland, chiefly planted with oak. The road from Bedford to Kimbolton passes through the parish ... The church, dedicated to St Mary, is an ancient edifice with a lofty spire. The interior contains an ancient font with an inscription. There is a National School built in 1840. The Baptists have two places of worship.' One Baptist chapel is on the far right of this shot of Keysoe Row; it is hardly surprising that Bunyan was arrested here for preaching at a secret meeting in Buryfields. (Z1306.69.2)

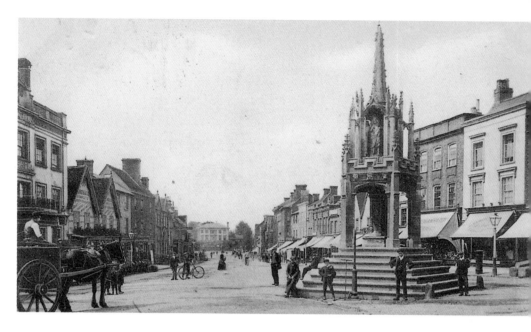

Leighton Buzzard: Market Place

'The town of Leighton Buzzard is built round three main streets, which form a Y, upon which all lesser streets converge,' the *Victoria* explains. 'At the junction is the Market Place, where there is a remarkable pentagonal cross which dates from the 15th century. It stands upon a base of seven steps ... The cross was repaired in 1650, when a tax of 4*d* was levied on each inhabitant, and was thoroughly restored in 1852 at a cost of £350. At the latter date some of the ancient statues were removed to ornament the town hall, a modern Gothic red brick building in the centre of the Market Place, which was also built at that period.' (Z1306.72.1)

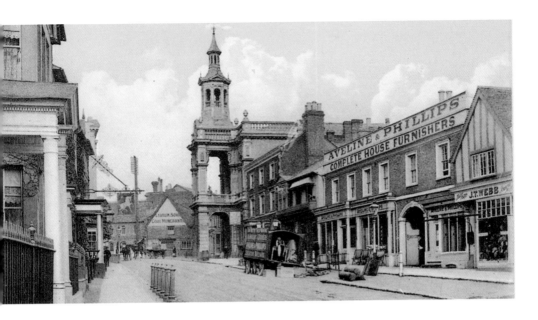

Leighton Buzzard: Lake Street

While the High Street has survived relatively unscathed, the entire north side of Lake Street has been obliterated. The magnificent Victorian Corn Exchange in the centre of the period photograph was built on the site of the old George & Dragon Inn and completed in 1863 at the cost of £7,500. In 1927 it was serving as the town's picture palace and contained a pub. By 1932 the spire was deemed unsafe and was taken down and, in 1968, shortly before it was demolished, Pevsner damned it as 'gay and vulgar'. On the left, the former Unicorn Commercial Hotel, housed in a late seventeenth-century building, has survived as The Lancer pub, offering Sky TV and similar attractions. (Z1306.72.3)

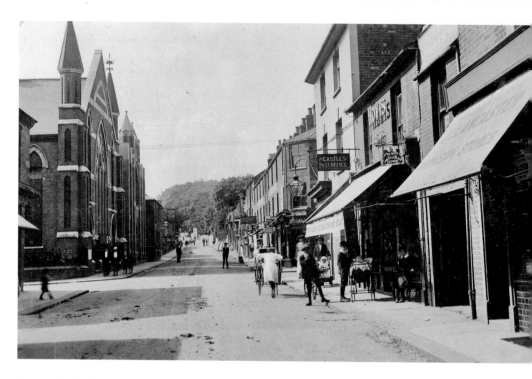

Luton: Castle Street

The *Victoria* speculated that the original settlement may well have been at a fording place on the River Lea. By the early sixteenth century, the town was famous for its barley market, but was in serious decline a generation later when a visitor wrote, 'I should say that at Luton I saw a fair church, but the choir there roofless, and overgrown with weeds.' Four centuries later, Mee tells us of a renaissance: 'It has clothed itself with the spirit of the 20th century and has become transformed within the memory of those not very old. Here is the biggest town in Bedfordshire, its population mounting to six figures, twenty times multiplied in a hundred years.' (Z1306-75-10-8-3)

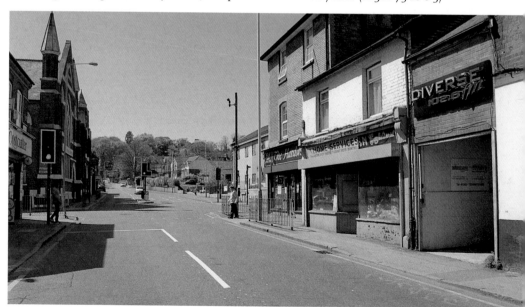

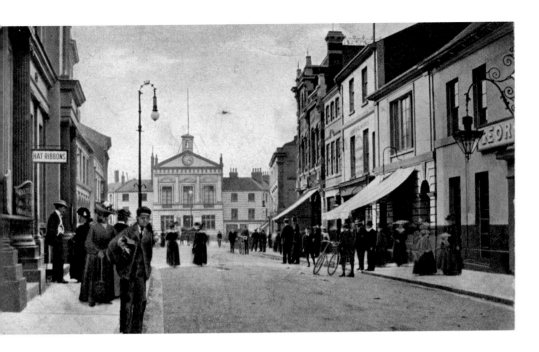

Luton: George Street

George Street in the heart of the town, the *Victoria* tells us, was the nexus of a web of narrow, steep streets 'so that the traffic ... often becomes somewhat crowded in the main streets, particularly on market days.' The post-war developers solved this congestion problem by driving a concrete dual carriageway on stilts through the south side of the town. They then bulldozed the centre to make way for the lovely, concrete-clad 1970s Arndale Centre – the largest covered shopping centre in Europe at that time, recently revamped as 'The Mall'. 'Luton's Town Hall, a civic block which would do credit to any county town,' is Mee's judgement of one of the few buildings that survived these 'improvements'. (Z1306-75-10-23-7)

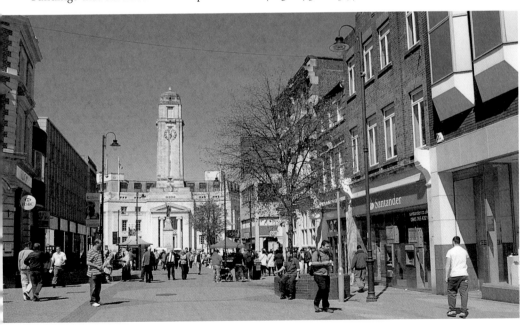

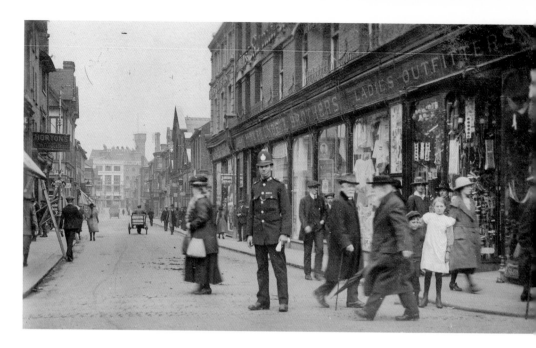

Luton: Cheapside

This was the heart of the town's once-flourishing straw hat trade. The *Victoria* explains: 'Tradition assigns the introduction of this industry to Mary Queen of Scots, who brought straw-plaiters from Lorraine to Scotland, and whose son James I, when he acquired the English crown, transferred the little colony to Bedfordshire ... In the beginning of the nineteenth century a further development ... took place when Thomas Waller obtained a patent for the manufacture of Tuscan grass plait, and since then a vast amount of raw material of foreign growth has been imported.' The main post office, built at the far end of the street in 1881, moved into larger premises in 1923 to cope with the boom in business. (Z1306-75-10-12-1)

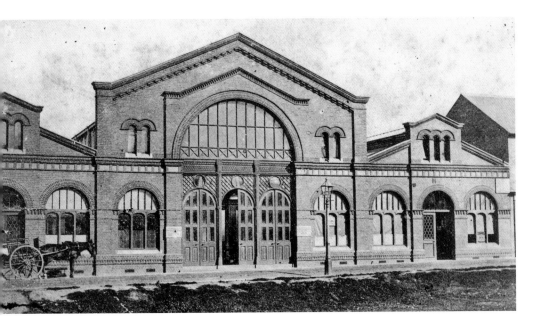

Luton: Straw Plait Industry

The spacious Plait Halls (*above*) were built in 1868 in Cheapside to accommodate a market that had outgrown George Street. Used for a banquet to feed the 'aged and poor' of the town for Queen Victoria's Diamond Jubilee, it was hardly surprising it could break all records for hat manufacture. However, by 1925, trade had diminished to the point where a general market took over the premises. In 1939, Mee reports that 'Luton remains the undisputed home of the straw hat, and with the changing fashions has developed the manufacture of hats in other materials, such as felt and velour. In one recent year the value of its trade in hats was between eight and nine million pounds.' (Z1306-75-17-27)

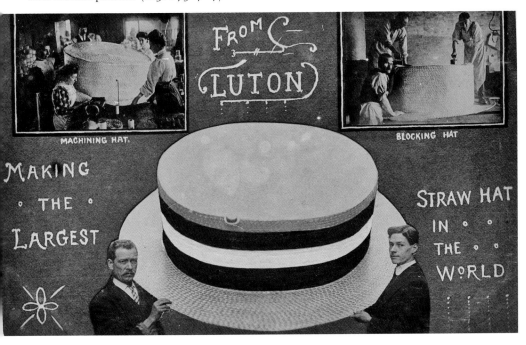

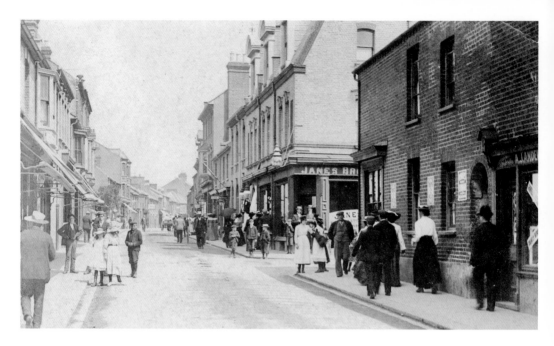

Luton: High Town Road

One of the major problems during the nineteenth century was to provide accommodation for the new workers streaming in to find employment in this burgeoning town. As early as the 1830s, an area to the north of the town, literally on the other side of the railway tracks, was used for cheap housing, which was quickly thrown up in what became known as High Town. Naturally shops and pubs sprang up to supply the everyday needs of residents – and their buildings in this street virtually all survive today. Although some areas here had been designated 'unfit for human habitation' in 1850, it took a century before a slum-clearance programme began in High Town. (Z1306-75-10-31-2)

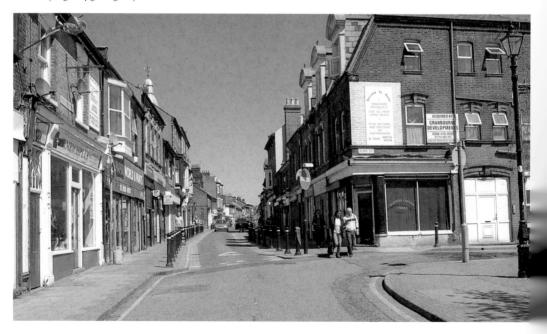

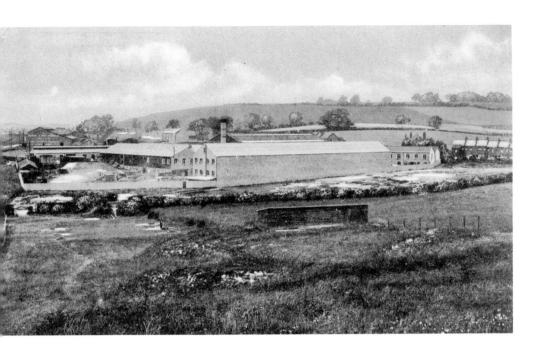

Luton: Vauxhall Factory

According to the *Victoria*, in 1917, 'besides the straw plait manufacture, (for which material is now imported from China, Italy, and Japan), there are in Luton iron and brass foundries, boiler works, and a brewery.' Surprisingly, even though the rapidly expanding Vauxhall Motors had moved up from London to open their first car plant just outside the town in 1905, they do not even merit a mention. However, after the First World War the company's sales were rapidly declining, and in 1925 the company was bought by America's General Motors because it gave them access to the huge markets of the British Empire. The new owners planned to introduce their mass market production experience and techniques to turn the company round. (Z1306-75-17-34)

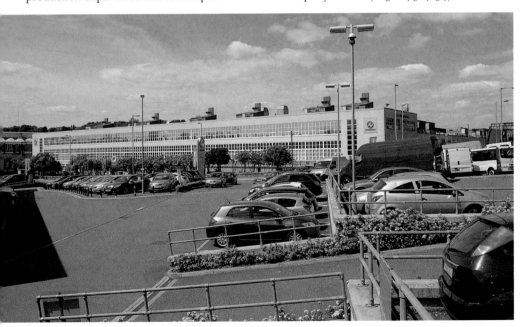

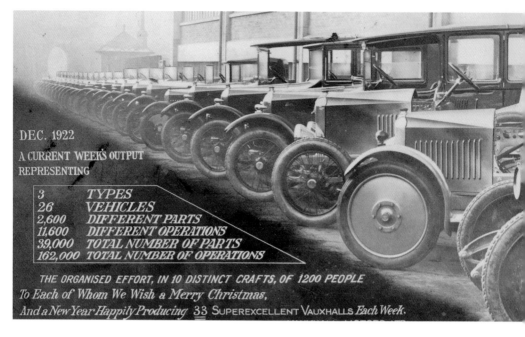

DEC. 1922
A CURRENT WEEK'S OUTPUT
REPRESENTING

3	TYPES
26	VEHICLES
2,600	DIFFERENT PARTS
11,600	DIFFERENT OPERATIONS
39,000	TOTAL NUMBER OF PARTS
162,000	TOTAL NUMBER OF OPERATIONS

THE ORGANISED EFFORT, IN 10 DISTINCT CRAFTS, OF 1200 PEOPLE
To Each of Whom We Wish a Merry Christmas,
And a New Year Happily Producing 33 SUPEREXCELLENT VAUXHALLS Each Week.

Luton: Vauxhall Motors

Having modernised production, General Motors' sales breakthrough came in 1933 when they launched the A-Type Light Six vehicles, closely followed by their B-Type larger models. Production grew from around 2,000 units a year in the late 1920s to over 22,000 by 1935 – Vauxhall had earned a place in the 'Big Six' of the UK motor industry league. The Bedford truck and van division set up in 1931 was so successful it quickly expanded into car-derived vans, tippers and passenger coach chassis. It certainly earned its future tag line, 'You see them everywhere', by becoming the vehicle of choice for the UK haulage industry and generating export sales all across the Empire. (Z1306-75-17-35)

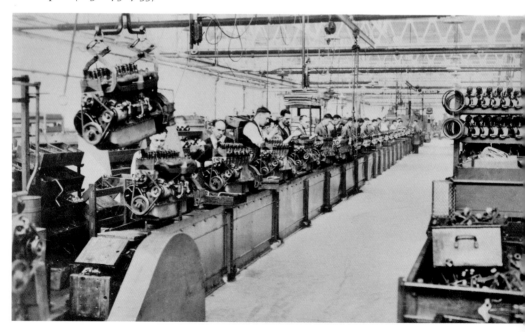

Marston Mortaine

Mee writes, 'The Morteynes were a powerful family of the Middle Ages, and it is reputed that the first Morteyne married a sister of the Conqueror.' However, the village is rather less grand than its illustrious heritage suggests – as the rather mean row of workers cottages with their ugly corrugated porches shows, built by one Robert Wills. The *Victoria* recounts a local legend relating to a large stone in a nearby field. 'A former owner of the field in which the stone is situated was playing at "jumps", probably another name for leap-frog, on the Sabbath, when the Devil took a leap from the church tower and, alighting on the stone, jumped with the offending party into eternity.' (Z1306.76.1)

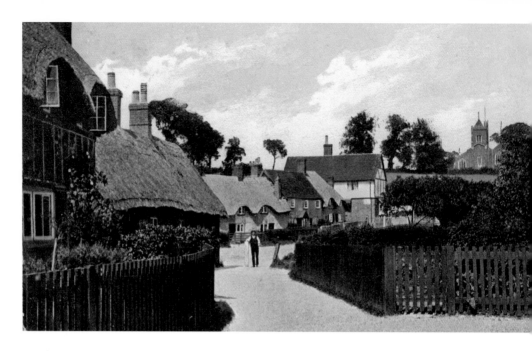

Maulden

Another strung-out settlement along a road, but this village is worth the drive. Here, the *Victoria* observes, 'is the White Hart Inn, an old thatched building having its walls covered with plaster. Situated on a hill and approached from the main road through a cornfield is the church, overlooking the village from the northeast. In the churchyard to the south of the church is the octagonal base and stump of a medieval cross.' While the White Hart still thrives as a smart gastropub, the George Inn in the centre of these photographs is closed and earmarked for extensive redevelopment – funded by building a new house in its grounds. Market gardening was once the villagers' main occupation. (Z1306-77-6)

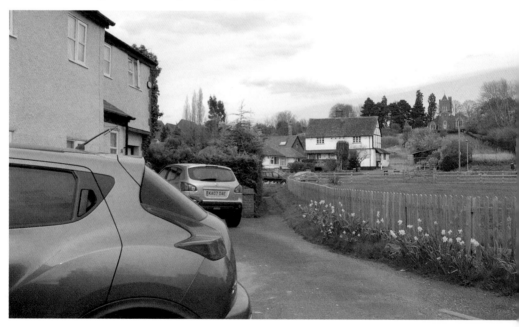

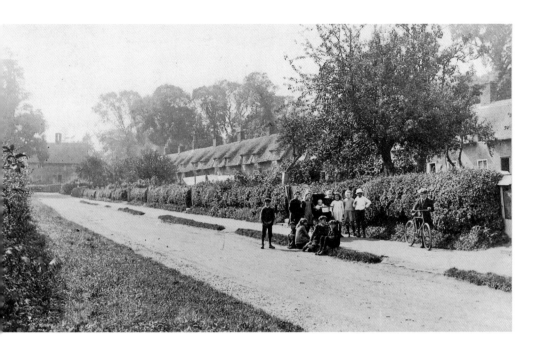

Melchbourne

'A lane with thatched cottages and bright gardens leads us to the great house, built from the spoils of the monasteries, and to one of the few village churches built in the classical style,' Mee notes. The latter properties are all over to the left, out of shot – this charming row of thatched workers' cottages are unspoiled, tucked away in this quiet cul-de-sac just off the main road. The *Victoria* tells us the village once contained, 'a preceptory of the Knights of Jerusalem ... The Knights Hospitallers had the right to hold a weekly market on Friday, and an annual fair on the vigil, feast and morrow of St Mary Magdalene.' (Z1306.78.1)

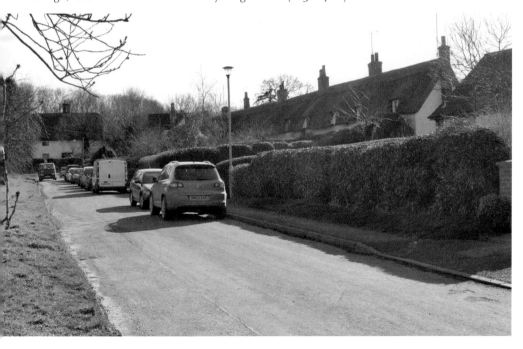

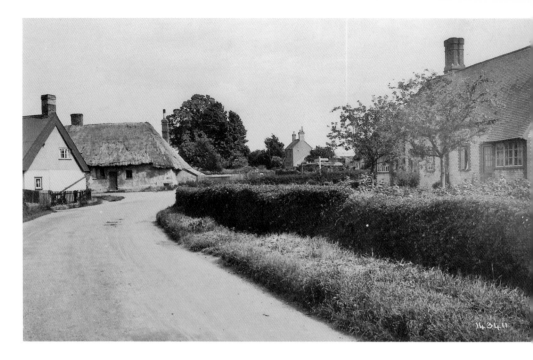

Meppershall

Clumped around a double bend and then dotted along both sides of what seems like several miles of straight road, this village has ancient earthworks near the church called 'The Hills', which Chambers tells us 'are either the remains of a moot-hill or a small "'burh"'. The Meppershall family, who took their name from the village, were Lords of the Manor for 300 years from the time of Henry III. The *Victoria* records that their stunning 'gabled timber and plaster manor-house, [is] now occupied as three cottages.' Today it is fully restored as a private home once again. The last remaining thatched cottage in the village, seen here, was probably built around 1690–1700. (Z130.79.3)

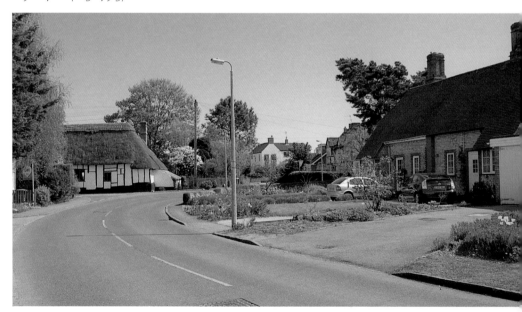

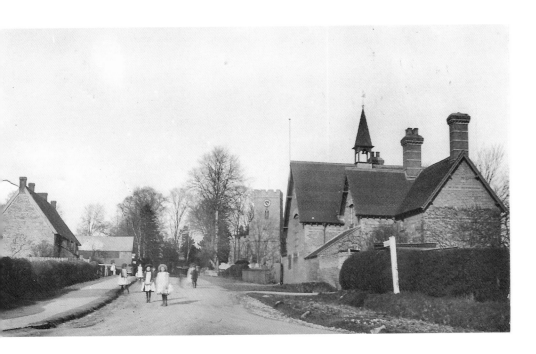

Milton Ernest

'It has splendid avenues of elms by the River Ouse, at Milton Ernest Hall: a great barn, some 17th century almshouses, a 17th century vicarage in a fine garden, and one of the handsomest church towers of the 13th century,' Mee summarises. The church, boasting architectural and decorative features from many different centuries, is still there despite being totally obscured by the mature trees in the graveyard. Unusually for such a small place, there was a printing press here in the eighteenth century, run by Underhill Robinson, who died in 1719. The village school still serves the local community as a Lower School accommodating fifty-eight children, using the village hall opposite for additional activities. (Z1306.82.1)

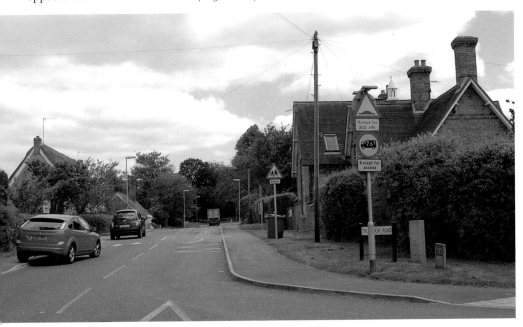

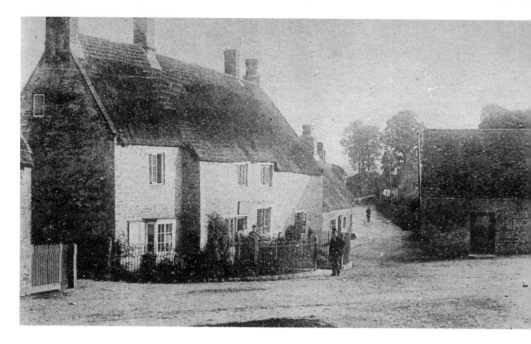

Odell: The Bell

'It is a village in which to pass a summer's day,' enthuses Mee, 'down among the thatched cottages by the river bend where the shady road sinks between a graceful church and the mound of a vanished castle here in Norman days.' The Bell, on the left, probably dates back to the seventeenth century and may not have originally been built as an inn. It first appears in written records in 1736 when the owner, a baker called John Amis, bequeathed it to his son. The property belonged to the Alston family, as Lords of the Manor, along with most of the rest of the village, until they sold it to a Bedford brewery in 1926. (Z1306.86.2)

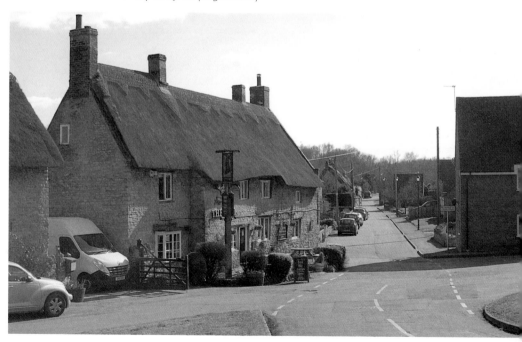

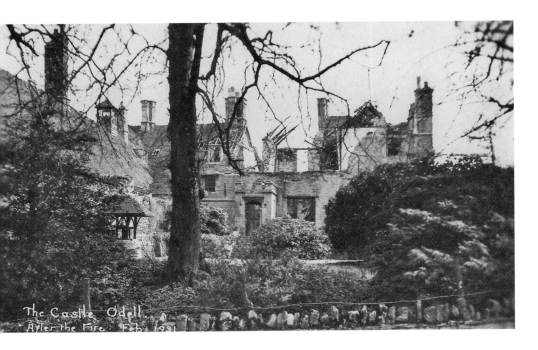

Odell: Odell Castle

In February 1931 *The Bedfordshire Times* had dramatic news to report: 'Odell Castle, was almost completely destroyed by fire on Tuesday ... It has a wealth of historical associations and in the reign of King John was used by that monarch as a hunting box.' Mr Rowland Crewe Alston, whose ancestors had owned the property for nearly 300 years, was fortunately no longer living there. 'The outbreak is believed to have originated in the boiler house.' The resulting ruin, shown in the original photograph, was sold off in 1934 to the first Lord Luke, but it was not until 1962 that the completion of rebuilding works allowed his son, the second Lord Luke, to take up residence with his family. (Z1306.86.1)

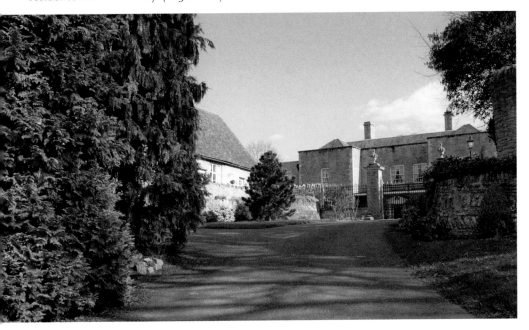

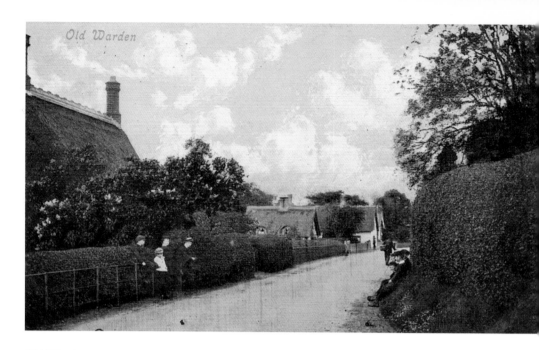

Old Warden

Fea describes a scene that remains the same today as when he was writing in 1913. 'The road descends into Old Walden, whose doll's-house cottages remind one of a kindergarten model village. Here the ornamental shelters of the pumps even have a fanciful fairy-story look; and the thatched inn, with its hilly background topped by dark fir wood, is quite like a peep into Devonshire.' Chambers adds that this picturesque village (with a population of 406) 'is the site of a Cistercian Abbey, of which only a few remains exist. It was the origin of the famous "Warden pear".' This fruit was cultivated by the monks and baked in Warden pies, later mentioned in Shakespeare's *The Winter's Tale.* (Z1306.129.3)

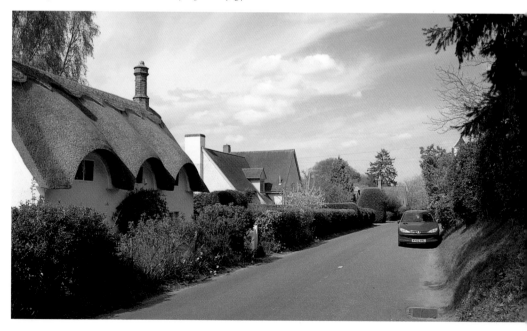

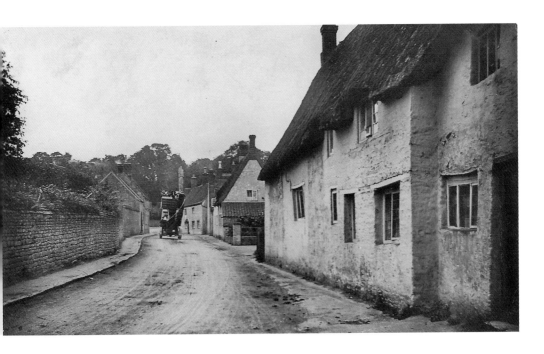

Pavenham

'The situation of Pavenham at a point on the Ouse where its tortuous course lends itself to the cultivation of osiers has led to the development of a considerable industry in rush matting and wicker baskets.' The *Victoria* continues, 'manufacture is said to date from the 17th century.' The local rush mats apparently covered the floor of the old House of Commons. 'The church, (St Peter), though small is interesting, with a broach spire, a widening nave and transept, and much carved oak,' Chambers adds. A plaque on the house just off camera to the right has 1489 on it – given the length of this meandering village this could be either a construction date, or the house number. (Z1306.87.2)

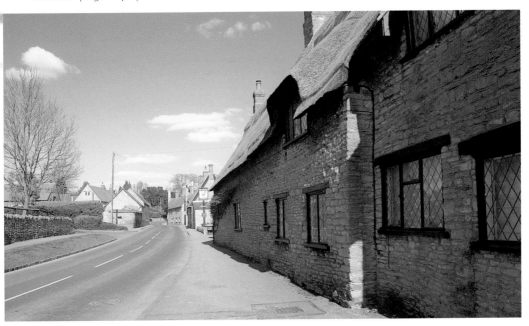

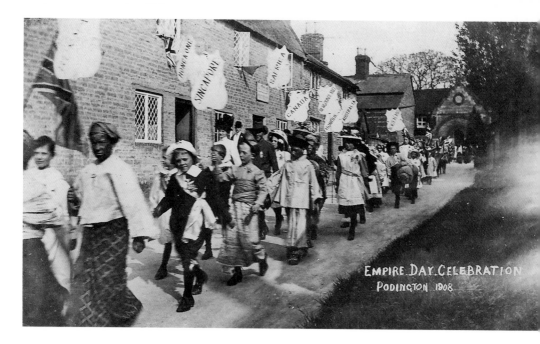

EMPIRE DAY CELEBRATION
PODINGTON 1908

Podington

The parents of these children, proudly parading in 1908 down Gold Lane in elaborate international costumes, clearly invested a considerable amount of time and money to prepare for the event. It seems their lives had materially improved compared to their eighteenth-century forebears, since the *Victoria* tells us, 'the making of thread-lace employed most of the women and children in this parish, whose health was declared to be "considerably impaired thereby, from their uneasy and confined position".' Half a mile from the village church, a field called Church Close was 'so called because it was intended to build the church there, but the devil used to come by night and remove the stones to their present site.' (Z1306.89.2)

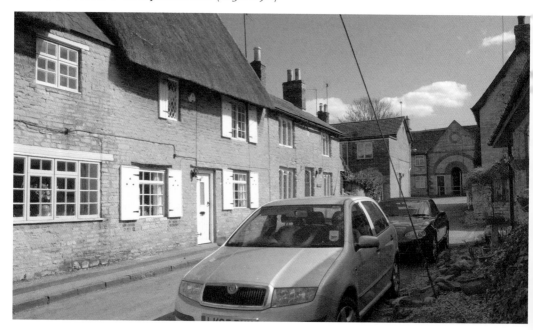

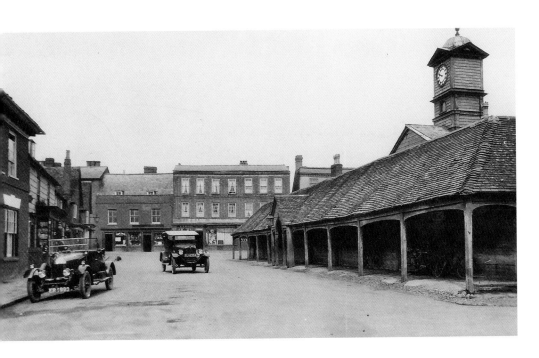

Potton

This charming market town is full of character, despite most of the historic 'shambles' market having disappeared. The clock tower building still serves the community as a bijou library. But Mee describes a very modern social experiment set up here, whereby unemployed families 'from the north of England are building up their lives anew. The land was given to them in 1934 ... to form the first estate owned by the Land Settlement Association. Here we found 26 families with over 80 children, each family in a little electrically lighted house and with 5 acres of land to develop. Each of the holdings have on it at least 30 bacon pigs, 150 poultry, and a big glass house.' (Z1306.91.1)

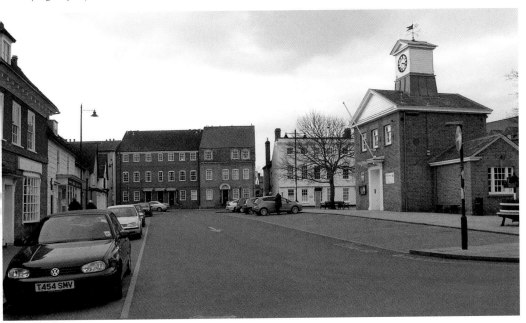

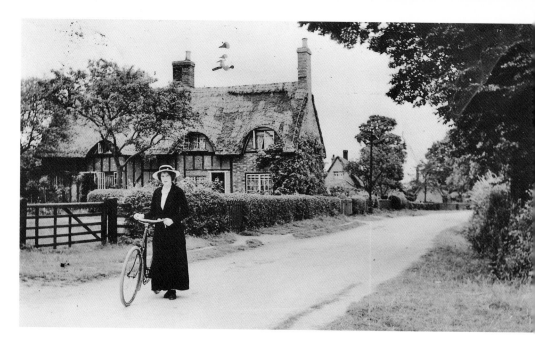

Renhold

The pretty Edwardian girl looks somewhat apprehensive at having been accosted by an enthusiastic photographer to adorn this photograph taken just before the First World War. A bicycle was a necessity for getting round a place that consists of no less that six hamlets strung out over several miles. The *Victoria* says the parish has nearly 1,000 acres of arable land. 'The principal crops are wheat, barley, peas, beans and oats ... The manufacture of bricks, tiles and drain pipes is carried on in the brickworks near Gadsey Brook.' The church is a hotchpotch of styles dating back over 750 years. The remains of earthworks above the River Ouse are thought to be fortifications built by the Danes. (Z1306.94.1)

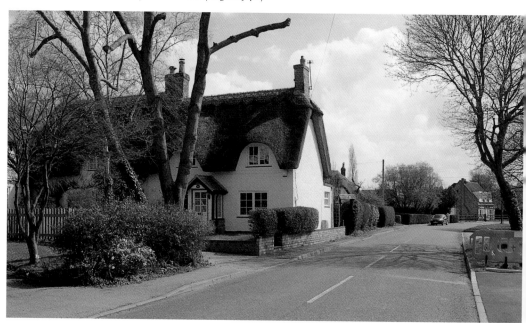

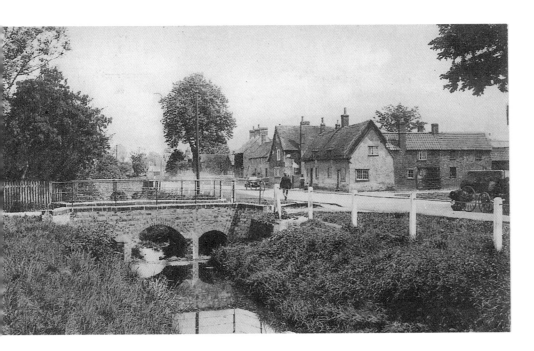

Riseley

'The village lies low, but west of the main street the ground rises and a windmill, which is still in use, has been built,' recounts the *Victoria*. 'Until recent years a water-mill also stood by the river. Two moats, one in the north and one in the south of the parish, probably mark the sites of ancient manors.' According to *The Comprehensive Gazetteer of England and Wales, 1894–95*, this large village had 'a post, money order, and telegraph office under Bedford, and a police station. The parish comprises 3,103 acres; population, 839 ... The church is a fine building of stone in the Early English, Decorated, and Perpendicular styles ... with a peal of five bells.' (Z1306.96.1)

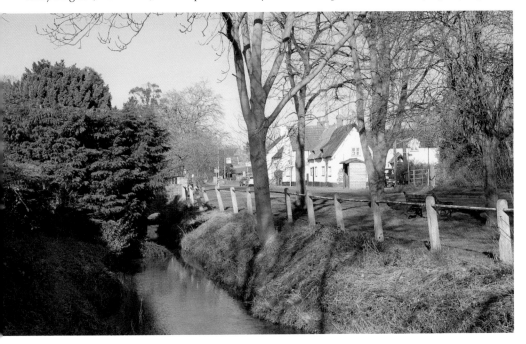

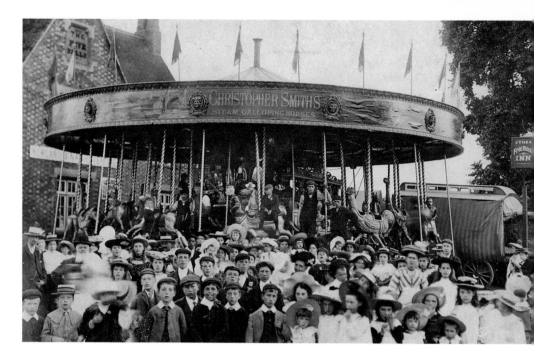

Riseley: The Five Bells

Named after the bells in the fourteenth-century tower of the church, the Five Bells Inn, originally a farmhouse, seems to have become a full-time coaching house in the early nineteenth century following the establishment of a turnpike trust in 1802. Business must have been good, as it was extended and refronted in 1866. The 1905 photograph shows an impressive merry-go-round in the pub forecourt for Riseley's Annual Fair, which ran right up to 1914. In 2009, the empty pub was sold and plans submitted to convert it for residential use. A vigorous two-year campaign by villagers to have it redeveloped as a family pub sadly failed, and it is now a private home. (Z1306.96.2)

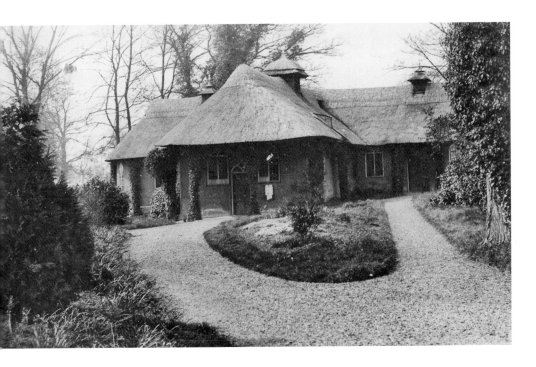

Roxton

The first entry in the 'Church Book' of this rare and charming thatched chapel reads, 'On 31 May 1808, a barn belonging to C. J. Metcalfe was opened for occasional preaching on Lord's day and other evenings.' In 1822 the barn was enlarged and altered to become an independent church, with wings added later in the century to accommodate the village school. When a flying bomb just missed the chapel in December 1944 to crash in a nearby field, the Church Book reads, 'The only damage done to the chapel was a fused electric bulb and a few small panes loosened. The bomb cut the overhead cable and cast us into darkness, but our minister calmly went on with his sermon.' (Z1306.97.2)

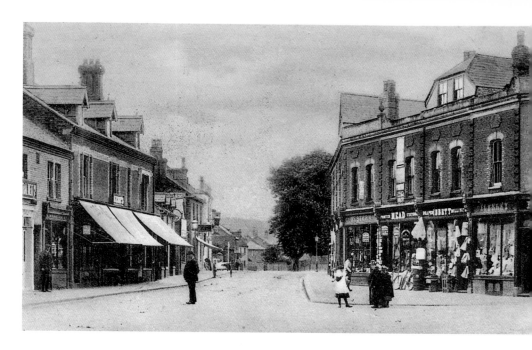

Sandy: High Street

Chambers describes this as a very large village, with a population of 3,377, 'situated under the range of sand hills. Owing to its soil and railway conveniences it has become a great market and other gardening centre ... "Galley Hill" and "Chesterfield" are undoubtedly the remains of Roman Camps. "Caesar's Camp" was probably a British stronghold, and the earthworks at Sandy Place possibly Danish.' Ancient coins, a funerary urn and bronze bowl were all unearthed in the nineteenth century. The fact that a whole parade of shops on the right, including a printers, stationers, drapers and milliners, has been displaced by the branch of a bank says something significant about the last century of change. (Z1306.99.1)

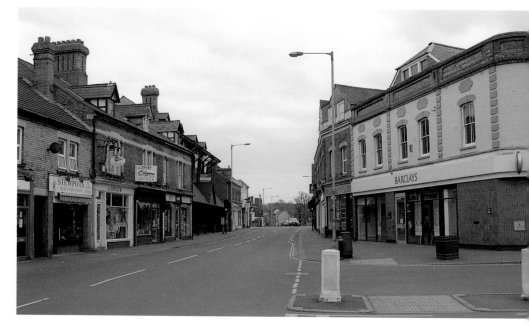

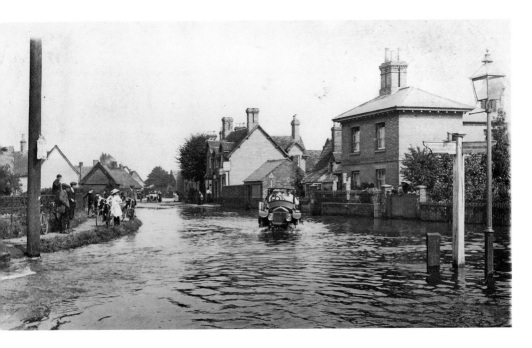

Sandy: London Road

Sandy has been at risk of flooding for centuries – the local stretch of the River Ivel is today designated as a Flood Warning Area – and here we see the consequences in August 1912. Fortunately, there were alternative transport facilities as the Great Northern Railway had opened a station in August 1850 and travel times to London had been cut to less that ninety minutes by 1890. The old Rose and Crown pub, whose sign is visible in the centre of both photographs, finally closed and was sold off in 2009 – it has very recently been replaced by a mews of modern town houses conveniently situated about 100 yards from the roaring traffic speeding along the A1. (Z1306.99.2)

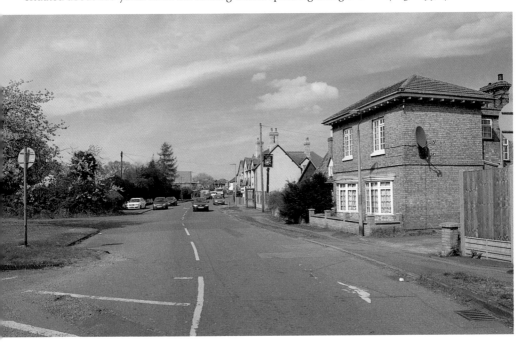

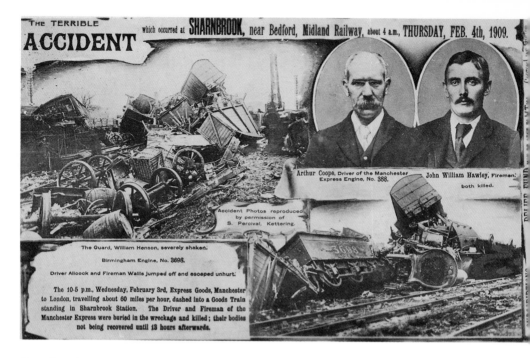

THE TERRIBLE **ACCIDENT** which occurred at **SHARNBROOK**, near Bedford, Midland Railway, about 4 a.m., THURSDAY, FEB. 4th, 1909.

Arthur Coope, Driver of the Manchester Express Engine, No. 388.

John William Hawley, Fireman; both killed.

Accident Photos reproduced by permission of S. Percival, Kettering.

The Guard, William Henson, severely shaken.

Birmingham Engine, No. 3698.

Driver Allcock and Fireman Wallis jumped off and escaped unhurt.

The 10-5 p.m., Wednesday, February 3rd, Express Goods, Manchester to London, travelling about 60 miles per hour, dashed into a Goods Train standing in Sharnbrook Station. The Driver and Fireman of the Manchester Express were buried in the wreckage and killed; their bodies not being recovered until 13 hours afterwards.

Sharnbrook

'Here sleep the citizens of Caesar's British colony', writes Mee, 'the Roman cemetery was laid bare in the building of the railway.' Perhaps an inauspicious sign, as this was to be the scene of a terrible rail crash on Thursday 4 February 1909. According to the official Board of Trade Report, the Down goods train from Bedford to Birmingham had been shunted to the Up passenger road on arrival at Sharnbrook. 'About 3.15 am the 10.5 pm up express goods train, from Manchester to London, was accepted on the up passenger road, under all clear signals, and a violent head-on collision ensued with the stationary train.' The driver and fireman of the express were killed and their guard severely injured. (Z1306.100.1/Z1306.100.2)

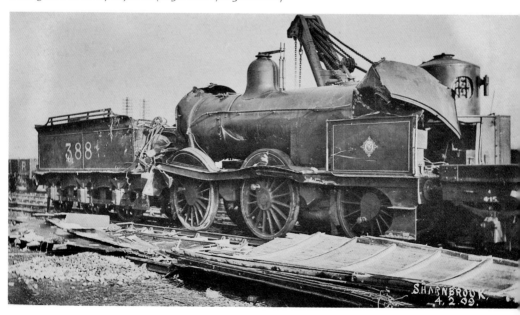

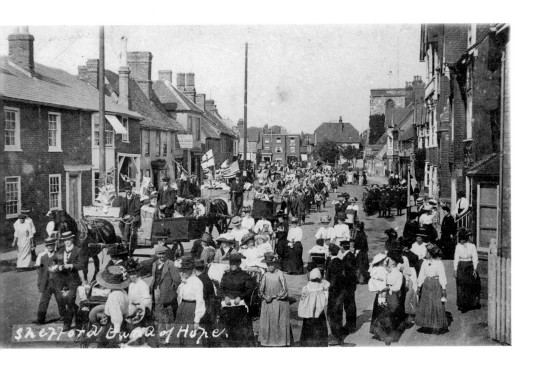

Shefford

The Band of Hope certainly attracted a good crowd in July 1912 – but perhaps free entertainment was at a premium in this small village. Fea observes that, although the church on the right of the High Street is supposed to be fifteenth century, 'excepting the tower, everything looks very modern. But skirting the wide street of this sleepy little market town there are some very charming old buildings – one block in particular having its overhanging storeys propped up by pillars after the fashion of the famous 'rows' of Chester. Shefford was an important place when Icknield Way was made, as is proved by the fact of the many relics of the period ... which have been discovered in this vicinity from time to time.' (Z1306-101-18-2)

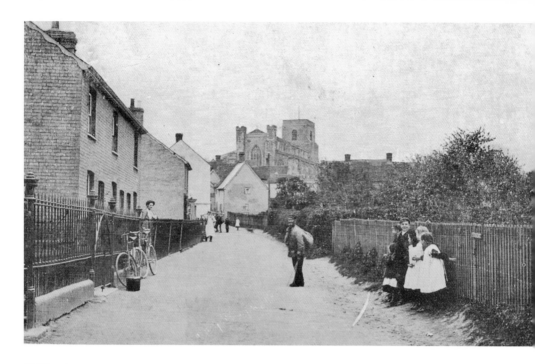

Shillington

This small village is blessed with three places of worship, but the jewel in the crown is All Saints church, especially approached via the scenic route up the hill through picturesque old buildings. The *Victoria*'s entry tells us, 'the building is one of great architectural merit, and of unusual design. Its plan is of the simplest, a great clear-storied hall running from end to end, broken only by the wide and lofty chancel arch, and flanked by aisles of the full length. It seems to have been begun from the east about the year 1300.' Mee continues, 'on the roof are patches of colour from the medieval days when churches were gay with it, and below is a crypt 700 years old, its vaulting resting on a pillar under the chancel.' (Z1306.103.1)

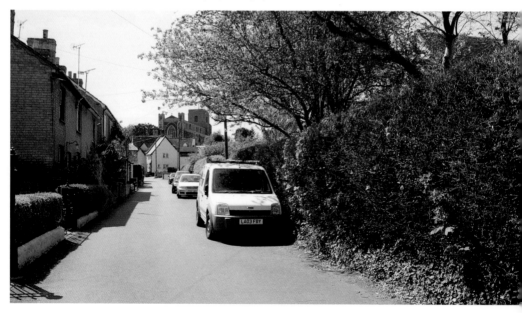

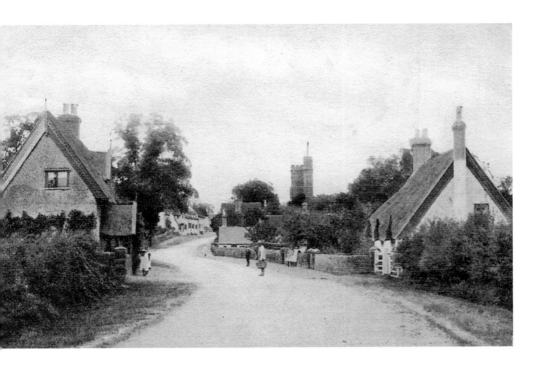

Silsoe

Originally known as Flitton cum Silsoe, due to being in the parish of Flitton until 1831, Mee enthuses, 'The main road has not spoiled it; it is still a bright place with its white gabled cottages roofed with old tiles; and its centenarian church has 16 windows rich with glass.' The *Victoria* informs us that 'there are many old clay, gravel, and sand-pits in the parish, most of which are now destroyed'. Although nothing appears to have changed since 1906, just off-camera to the left of the modern shot is 'The Meadows' – a 'stunning' new development of more than 200 homes in 'the enviable setting of one of South Bedfordshire's most desirable villages'. (Z1306.104.2)

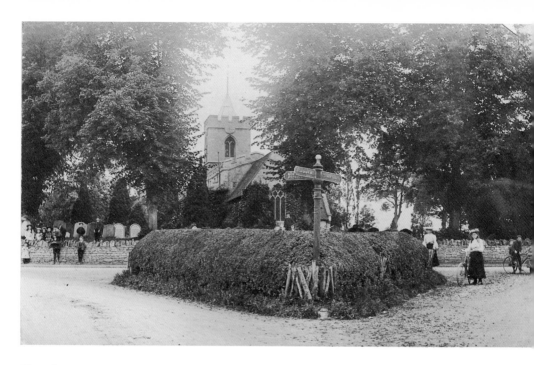

Stagsden

'It is one of those rare villages where we find thatched cottages and electric light together.' Mee explains, 'Its name comes from its first vicar, who came here in 1220, Reginald de Stacheden. The church he knew still stands by the old thatched barn (which we found in ruins) shaded by great limes and sycamores in a churchyard level with the top of the wall.' He would probably be pleased to hear there is now a popular local farm shop in the farm adjacent to St Leonards, the west tower of which dates back to the thirteenth century. 'In the early part of the 14th century a south aisle and south porch were added,' the *Victoria* reports. (Z1306.107.1)

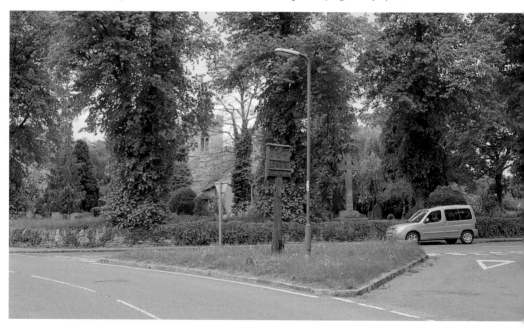

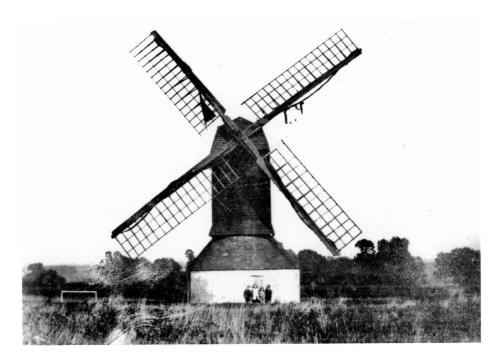

Stevington

Mee waxes lyrical about this 'magnificent 18th century post mill, notable for still possessing the real old-fashioned sails, or sweeps, such as can be furled or unfurled.' The only complete mill of its type left in Bedfordshire, it is constructed around a central post so that it can be turned to face into the wind and was operated commercially, mostly grinding cattle feed, until 1939. It was purchased by Bedfordshire County Council and restored in 1951. '"Drinking-Bush Hill" is the name of a hill towards the western boundary of the parish,' explains the *Victoria*. The parishioners, '"beating the bounds" on arriving at this place, used to dig a hole, jump in it, and then drink to satiety.' (Z50-112-20)

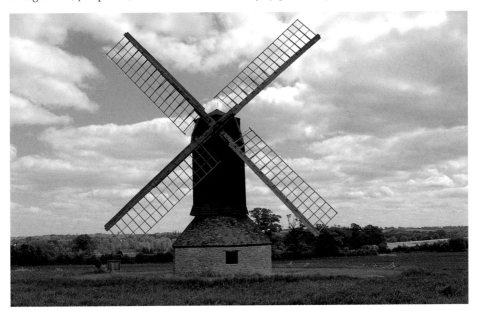

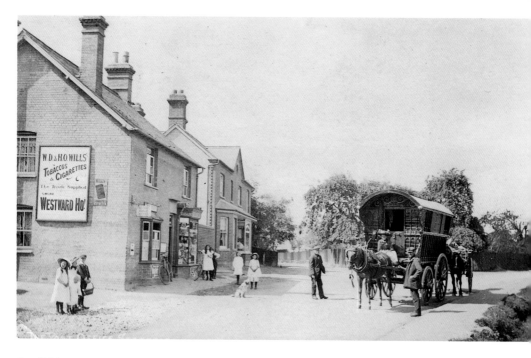

Stotfold

'The surface generally is flat, and the village lies about the middle of the parish, spreading over a considerable area just north of the line of the Arlesey Road ... the outlying parts of the village to the north and south are known as Stotfold Green and Brook End. There are many old cottages, but no buildings of much architectural interest,' so says the *Victoria*. This charming Romany caravan, parked outside the post office around the turn of the last century, would have no difficulty recognising the junction of the High Street and Brook Street today. The same could not be said for the rest of the village, which has seen major changes in the modern era. (Z1306.115.2)

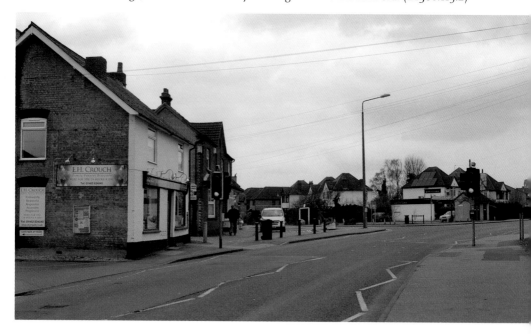

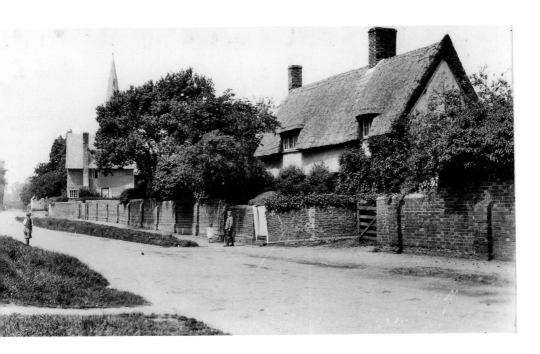

Swineshead

This prosperous and picturesque village tucked away in the wilds of northern Bedfordshire seems to deserve a more charming name. 'Swineshead was formerly in Huntingdonshire,' the *Victoria* explains, 'but in 1888 it was transferred to Bedfordshire, to which county it has always geographically belonged.' The elegant spire in the background belongs to the parish church of St Nicholas, which Chambers tells us 'has many details worthy of study – a canopied Easter sepulchre, carved stalls, etc.' Mee points out that 'four corners look down from the corners of the tower on a perfect country scene, and there are many surly faces on the church, a little out of place in the smiling countryside.' (Z1306.120.1)

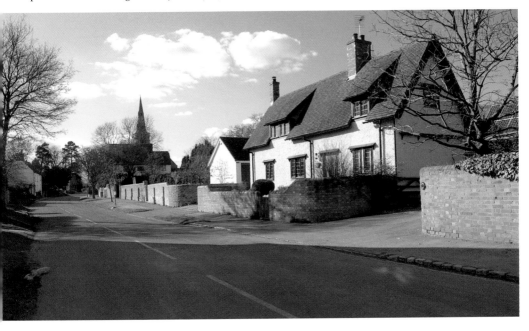

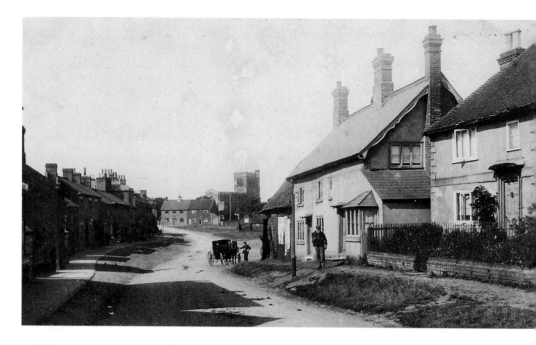

Toddington

The fact that Toddington reached its peak as a thriving market town in the eighteenth century accounts for the air of prosperity that it retains today, and for what Chambers describes as 'a fine cruciform church with central tower, the nave arcade and part of the tower being Early English. 'It is specially interesting for its monuments.' Mee elucidates, 'Its rich wool merchants in medieval days made of its ancient church a veritable treasure house, and gave it a zoo before Whipsnade. A long procession of birds and beasts and men, with a mermaid, a phoenix, and a chained bear run around its outside walls.' The smithy forge is long gone from the green, but the grand iron village pump remains. (Z1306.126.2)

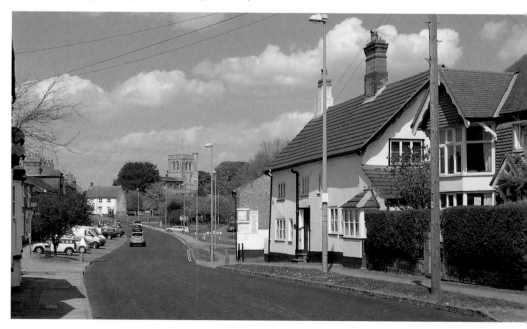

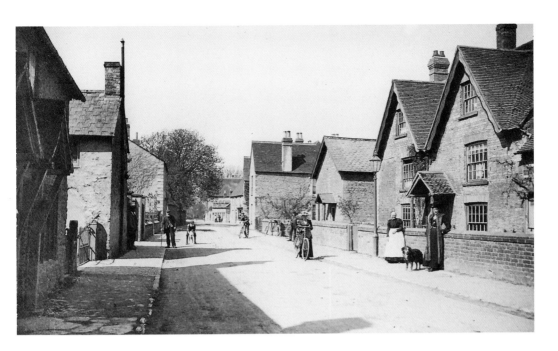

Turvey: High Street

Fea gives us some facts: 'The approach to the town … is beneath an avenue of trees. This air of distinction is endorsed by the well-built, uniform, and prosperous-looking dwellings. Near the village smithy [*see page 5*] is "Nell's Well", a natural spring, the outlet of which has an alcove of modern masonry. But who was Nell? We made inquiries, but nobody knew anything.' He continues, 'at the eastern end the first house encountered going Bedford way stands an ancient hostelry, The Three Fishes … The suggestiveness of the pictorial sign of three plump specimens (trout, perhaps) in combination with the promising presence of Jonah, the seduction of cetacean sport must induce many piscators to try their luck at Turvey.' (Z1306.128.1)

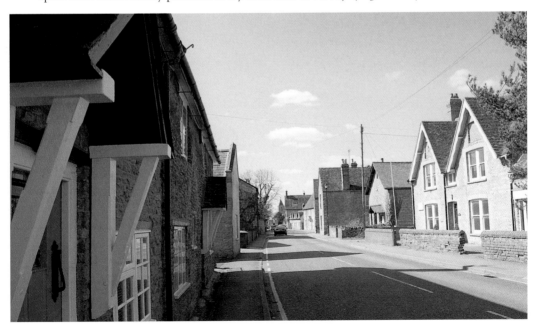

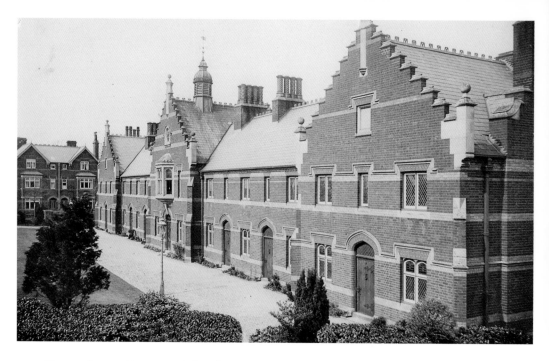

Turvey: Barton Homes and the Three Cranes

According to the extensive and informative village website, the grand almshouses (*above*) were built in memory of his two sisters by James Barton in 1885 to house 'twenty people of good reputation and character' – ten individuals were given 6*s* (30p) per week, and ten married couples received 8*s* (40p). The building was demolished in 1966 and replaced with modern bungalows. 'The Three Cranes Inn, formerly known as the Chequeres,' the *Victoria* reports, 'has been much modernized and is of very little interest.' To twenty-first-century eyes it still has considerable charm and apparently serves great Sunday lunches. The outbuilding to the left obscured by the Bedford Omnibus is now a butcher's shop, famous for their 'Burley Bangers'. (Z1306.128.3)

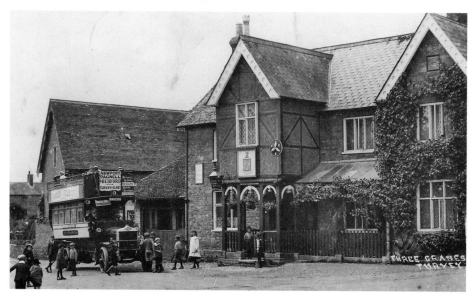

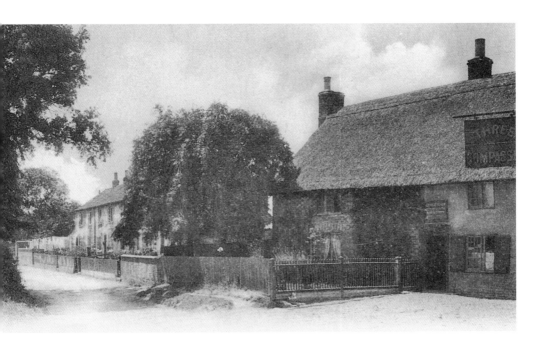

Upper Dean

Although built around 1700, and reputed to be a(nother) haunt of Dick Turpin, the Three Compasses first gets a mention in the Alehouse Licensing Register of 1822. In 1876 it belonged to Day & Sons Brewery of St Neots, but by 1927 it was owned by the Bedford brewer Charles Wells and listed as having extensive outbuildings including a barn, several piggeries, stables and a coach house. However, the valuer reported, 'House does not pay rent, no trade and is on parish. No spirits sold, absolutely dead house.' Things had apparently improved by 1938, since a note in the register states, 'Old outbuildings pulled down, now has garage.' Today, the pub is the only one in the parish of Dean and Shelton. (Z1306.35.2)

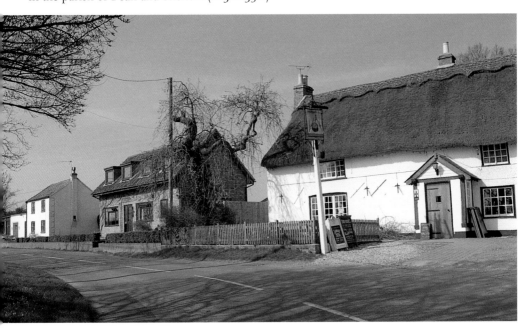

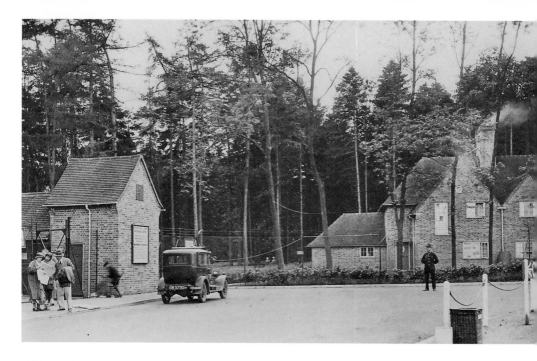

Whipsnade

When Mee visited in 1939, the London Zoo's country site had only been open for eight years. 'Beyond the village the road runs beyond Whipsnade Green to a dark and dense pine grove ... In the shade of these trees is the main entrance to 500 acres of woodlands, meadows and downs where hundreds of wild animals roam in natural freedom.' In 1927, the area, previously known as Hall Farm, was purchased for £13,480 12s 10d and redeveloped for the animals over the next three and a half years. The Duke of Bedford donated wallabies, muntjac and Chinese water deer from nearby Woburn Abbey in 1928 – their descendants still live at the zoo today. (Z1306.131.3)

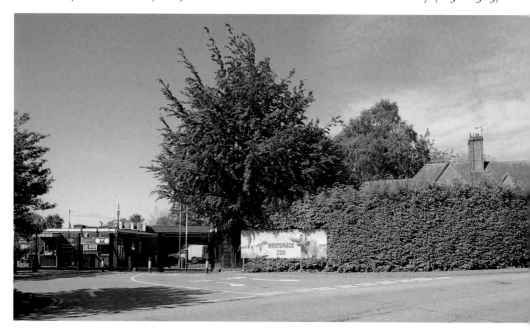

Whipsnade

At its opening on Saturday 23 May 1931, some 1,080 people braved the rain to visit the zoo. By the Bank Holiday Monday at the end of the month, a staggering 26,946 visitors entered the zoo – the highest attendance figure ever for a single day. The roads were jammed by cars for miles around. The train from St Pancras to Luton was cancelled to prevent more people arriving and adding to the congestion. 'We did not meet the elephant making a real tramp abroad but he does, and camels do too. There are frogs and lizards in a pond, cranes and storks, and baby animals born into happy surroundings, infinitely happier than it they were cribbed and confined in the smoke-laden town.' (Z1306.131.2/Z1306.131.1)

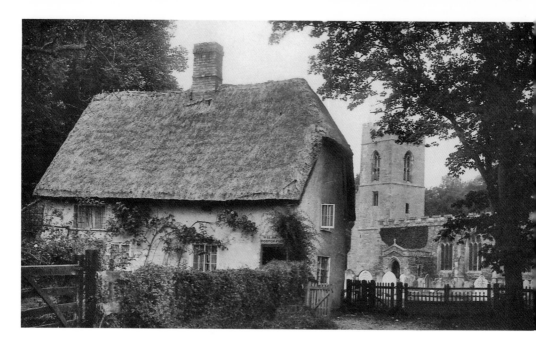

Wilden

'Wilden village, which is somewhat straggling, is situated in a hollow mainly in the centre of the parish, having the parish church of St Nicholas, standing in a graveyard surrounded by trees, as a nucleus.' And today it is still exactly as the *Victoria* describes it. 'The cottages are of brick and are of varying date; the older ones have tiled and thatched roofs, the more modern have slate. South Brook runs almost parallel with the road, and is crossed at intervals by foot-bridges.' The explanation for the large number of hamlets found in this small parish is that in the Domesday Book, 'Wilden was owned by twenty-four sokemen, these various districts possibly marking their "wics" or dwelling-places.' (Z1306.132.1)

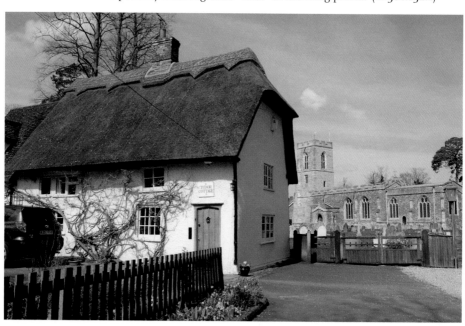

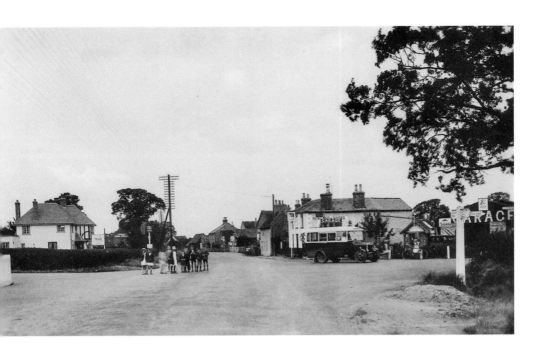

Wilstead

'Most of the cottages are quite modern, though there are a few examples of thatch,' the *Victoria* tells us about this ancient settlement, formerly known as Wilshamstead. 'At the west end of the village … is an early 17th-century uninhabited brick farm-house, while on the opposite side of the road is a modern saw-mill. Beyond this is the part called Duck End, north of which … is a brick kiln.' Mee adds, 'There is a charming 15th century church house by the churchyard gate, which Henry VIII gave away when he took for himself the estates of the church, but which Queen Elizabeth ordered to be given back to the village for a school, for wedding breakfasts, and other purposes.' (Z1306.134.1)

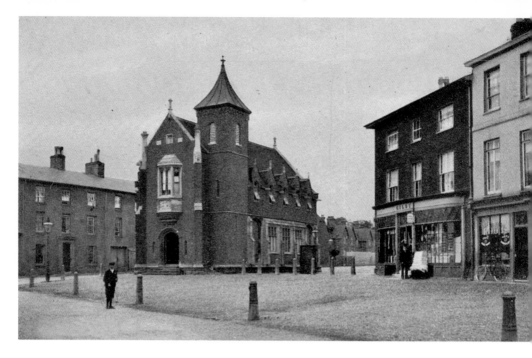

Woburn: Town Hall

This charming and wonderfully-preserved Georgian market town clusters around the gateway to Woburn Abbey. According to Chambers, 'the seat of the Duke of Bedford, was a Cistercian house, of which no remains exist. The present mansion was built in 1744, and contains a notable collection of pictures and sculpture; the park is one of the largest in England and is celebrated for the very fine zoological collection.' The market hall, erected in 1737 right outside his park gates by the fourth Duke of Bedford, was replaced by the Town Hall in 1830. The building was restored in 1884 at which date the library of the Woburn Institute was removed from the building. (Z1306.135.1)

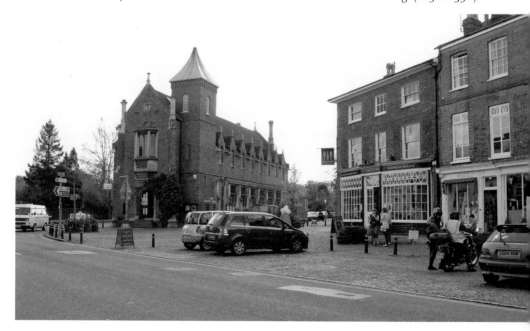

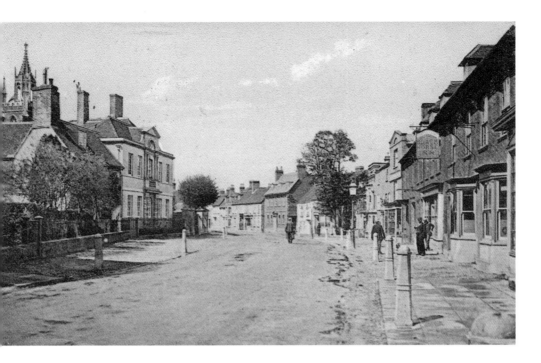

Woburn: High Street

'Of the Eleanor Cross which formerly stood in Woburn, probably in the market place, no trace now remains. It was begun in 1292, rather later than most of the other crosses. A great part of the work was done by Ralph de Chichester, and the total cost of the whole cross was £60 6s 8d,' the *Victoria* reports. 'Almost destroyed by fire in the eighteenth century, Woburn was reconstructed with much charm and dignity,' writes Mee. 'The grand old Georgian Inn hangs out the gay sign of the Bedford Arms, and it is one of the oldest places here. The old church was found too small for its congregations and was pulled down.' (Z1306.135.2)

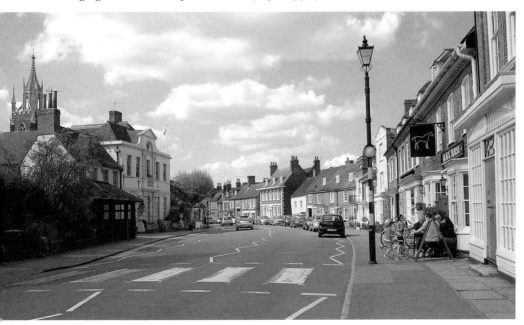

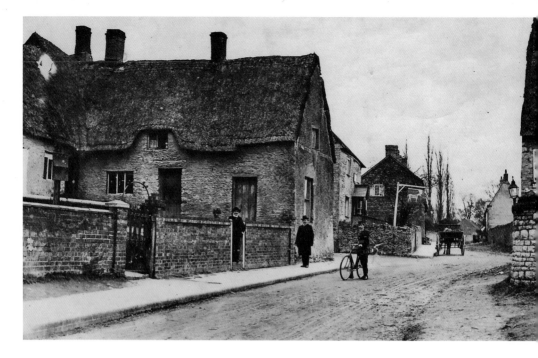

Wymington

Chambers sings the praises of the village's church of St Lawrence: 'With a fine spire, good brasses, and two octagonal turrets at east end, like those of Shillington. It was entirely rebuilt by John Curteis, Mayor of the Wool Staple at Calais, who died in 1391.' However, the *Victoria* reports a traveller's 1785 description of the place as, '"an obscure and ruinous village consisting of thirty-five indifferent stone houses, all but one covered with thatch," with a population of 216, which in 1901 had increased to 509.' It is obviously sad to see the White Horse pub on the left boarded up, but the nearby ancient New Inn still serves a great lunch for today's weary traveller. (Z1306.138.1)

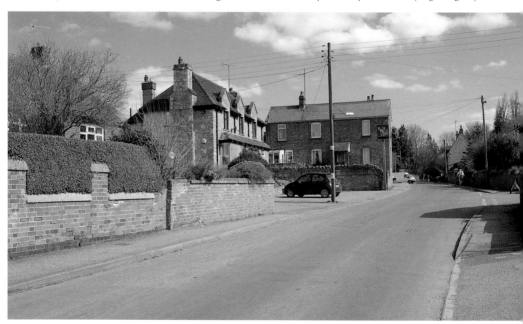